FRENCH WATERCOLORS
OF THE 18TH CENTURY

Toutes ces petites particularités je vous les dis parce qu'elles ne sont pas si bagatelles qu'elles paraissent

Marivaux

FRENCH WATERCOLORS OF THE 18TH CENTURY

PHILIPPE HUISMAN

A Studio Book

THE VIKING PRESS · NEW YORK

FRENCH WATERCOLORS OF THE 18th CENTURY

Copyright © 1969 by Office du livre SA, Fribourg
All rights reserved

Published in U.S.A. by The Viking Press, Inc.
625 Madison Avenue, New York, N.Y. 10022

Published in Canada by
The Macmillan Company of Canada Limited

Library of Congress catalog card number : 69-14466

Printed and bound in Switzerland

English-language translation by Diana Imber

CONTENTS

Why does a sketch please us more than a good picture? It is because there is more life in it, and less defined forms. As forms become more accurately defined, life departs. In dead animals, the forms are there, but life is gone. In young animals, birds or kittens, the outlines are not strongly marked, yet they are full of life and therefore please us greatly.

Why is it that a pupil who is quite incapable of painting even a tolerable picture can make a striking sketch? It is because a sketch is the work of enthusiasm and genius, and the picture is the result of industry and patience, long study and mature experience of art.

Who has found the secret which Nature herself does not possess of keeping the life of youth in the forms of advanced age? Perhaps one reason why we are strongly attracted by a sketch is that being undefined, it leaves our imagination free to see what we like in it, just as children see shapes in clouds—and we are all more or less children. It is the same difference as that between vocal and instrumental music: we listen to what the former says, but make the latter say what we choose.

We make four perpendicular lines and suddenly they are four columns of fine proportion; a triangle across the top of these columns becomes a pediment and we have a piece of noble and elegant architecture—once the proportions are given, imagination steps in. Two lines which have no shape in themselves, if pointed forward give us two arms; two more such lines and we have two legs; a dot in an oval for each eye; another unfinished oval and we arrive at a head, and a figure that moves about, runs, sees, and shouts. Movements, action, even passion are suggested by a few essential lines and created by my imagination. I am inspired by the feeling of the artist, *Agnosco veteris vestigia flammae*; a single word awakens great thoughts in me. In the violence of passion man does away with all links; he starts a sentence and stops short; he utters one word, cries aloud, and is silent; but I have heard everything—this is the sketch of a speech. Passion deals only in sketches. And what of a poet who always fills in every detail? He is turning his back on Nature.

Denis Diderot
in *Salon of 1767*

6

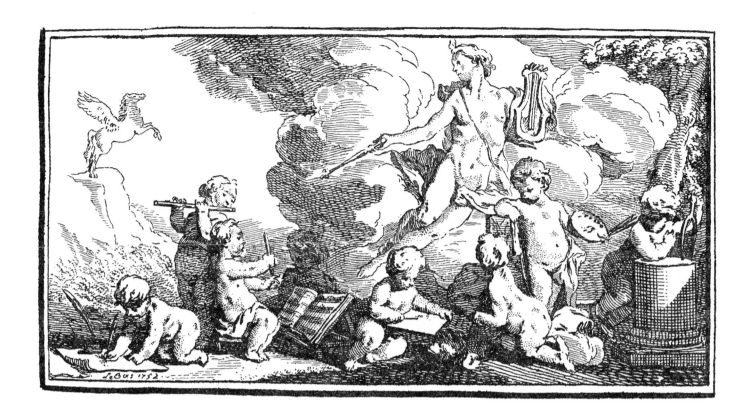

INTRODUCTION

Caelestibus Monicae Oculis

The fabric of our lives is woven of hope and forgetfulness. In our instinctive and often desperate effort to preserve a long-awaited, already vanishing moment, in the unequal and passionate struggle to save something of our joys and of our loves, writing or painting, reading or looking are simply the reflexes of defense. The picture defies time and defeats death. Sometimes it takes conscious form and is planned, like a monument created over a long period of time, or like the kind of painting which is a refashioning, rather than a reflection, of a particular landscape or a moment. Drawing is quite different, because it forms part of the plan, of the dream, and its precision of line and expanses of white relate it to the mind.

Watercolor can catch a moment, a quick smile, a falling leaf, an elusive ray of sunlight. It is a technique subject to all the uncertainties, hazards, and frailties of time. It can never be completely premeditated: the colors pass from the brush to the paper, flowing freely and occasionally mixing capriciously. No process is as simple, or as quick.

Watercolor paints were sold at the time of Louis XV in boxes of about the same size as the paint-boxes sold to amateurs today. With a brush, water, and tubes or blocks of color, freedom of action is assured. The experienced watercolorist needs hardly more time to record a movement than his model takes to carry it out. His is an art of improvisation. And it is elusive even when the painting has been made; if a watercolor is continually exposed to bright light it softens and fades, is effaced like the charm of a human face, of a flower, a memory.

The eighteenth-century watercolor, nowadays so rare, has the charm of intimacy. Watercolor painting has always been practiced, but even in the reign of Louis XIV no word had yet been invented to designate the technique. It was no chance that this century of impromptu ideas, stories, diaries, secret confessions, court balls, and popular *fêtes* was so enthusiastic about watercolor painting that it raised this spontaneous, everyday method of sketching and coloring to the dignity of an art. The century of movement, novelty, and light, a century blind to the eternal realities, could scarcely have left a truer image of itself. An unmade bed, a walk through a sun-lit garden, a seductive yet sophisticated Venus, a flower from the king's garden, burning logs behind a mound lighting up the Trianon of Marie Antoinette with their glow, such are the fair moments which have been effaced, erased for two hundred years, and yet which can be glimpsed and enjoyed by us in the beautiful watercolors that have been miraculously preserved all this time.

A painting made with pigments mixed with water has a transparency that distinguishes it at once from a pencil drawing or the opaqueness of a pastel or oil painting. But it is just as artificial to isolate watercolor painting from other art techniques as to try to fix the bounds of poetry. All pictorial means of expression are related.

Frequently a watercolor is painted over a prepared drawing, and a pen-and-ink drawing is only distinguishable from it by the smaller variety of colors. Even the water in a watercolor is rarely absolutely pure, and it often leaves a faint shade of its own on the paper. Glue mixed with the color was an early method of holding the pigment to the paper, once the liquid had evaporated, but if the glue was too thick and the water less abundant the transparency was lost and the result was a gouache. Today it is possible to buy colors specially made either for a gouache or a watercolor, but in the eighteenth century the same colors were used in a more or less dilute condition. Hence the frequent mixing of the two techniques by the most brilliant artists of the century, such as Louis Moreau or Saint-Aubin, who enhanced a detail in gouache in a scene otherwise painted entirely in watercolor; the miniaturists also, sometimes using the color of the support to emphasize the transparency of a clear skin or to stress the rich texture of a heavy cloth, painted very small works in both gouache and watercolor.

Artists engaged in large-scale work, such as painting a stage set with watercolors, are confronted with the same basic problem as the sketchbook watercolorist and must be capable of the same spontaneity. The fresco painter applies his colors with water alone over a wet slip that absorbs the liquid and retains it as it dries. Fresco painting is no more capable of correction than the words of an actor or an orator, or the work of a watercolor artist. If he tries to improve on the first attempt his work becomes less coherent and heavy. Watercolor, essentially, bears something of the elemental nature of water, its mysterious transparency and volatility.

To be a watercolorist is to be a poet with a brush; the attitude and sensitivity of the artist is more important than his choice of method. It would seem to be as illogical to exclude prose poems from an anthology of poetry as to exclude gouaches and washes from a collection of eighteenth-century French watercolors. To appreciate the originality and unity of this school, a brief study of the history of its techniques is essential.

The origins of watercolor are lost in antiquity. Water is certainly the most common natural liquid for dissolving colors: the petals of a flower crushed between our fingers provide a watery stain; puddles after a shower, taking their color from the earth, are red or brown. Nature has always placed watercolors at man's immediate disposal. But water evaporates in the hand and from the ground; all that is left is a pinch of colored, evanescent dust. Watercolors exist in nature, and the problem then is to find a way of preserving them and fixing them on a support.

The fragile colors found in prehistoric rock paintings present one of the first attempts by man to find such a solution. The most varied animal and vegetable colors were known in antiquity, and potters applied watercolors to their work and fired it in kilns. Roman interiors, on the other hand, were covered with mosaics, a surface of small colored stones, or with wax paintings, and hence the designs tended to be geometric. When a painting was to be made on a wall, fresco applied onto drying plaster was a technique developed by the artists of medieval Europe. Paper, an essential element of the modern watercolor, only came into use among painters during the early Renaissance. Vellum, during the first centuries of our era, was the natural support of watercolor painting.

Color pigments were ground, dissolved, and mixed with all kinds of adhesive substances: wheat-flour paste, white or yolk of an egg (the primitives), animal glue (for tempera), and casein of cheese (favored by the Flemish primitives). Such paintings in watercolor may be opaque and brilliant, nearer in fact to oil painting.

Manuscripts on parchment were illustrated in watercolors up until the fourteenth century. However, it would not be correct to speak of creative watercolor painting in this connection, for the monks were decorating books (and designing letters) without an original model, and it was really a question of coloring; every motif was carefully and minutely drawn and the outline finished before the brush was taken up. However, as watercolors were used for filling in a design, medieval manuscripts are the first stylized examples of an art which becomes progressively freer throughout the centuries.

Before the discovery of oil color, which was the outcome and final perfecting of egg tempera, the illuminators of the fourteenth century used either transparent or opaque colors, the latter probably being easier to blend with the gold which was traditionally used. The process we call gouache must have seemed a great technical advance to watercolorists at the same time that oil painting and casein painting

9

began to revolutionize the art world in the fifteenth century. Watercolor continued to exist as a useful technique for less artistic works: diplomas, coats-of-arms on parchment, architectural plans and topographical prints were, as they would always be, washed with watercolor. For many years watercolor now remained largely the painting of the poor man: it was a Gothic procedure and out of fashion.

But two great artists ensured the continuance of this despised technique. Holbein was one of them, and his miniature of Anne of Cleves, made in watercolors sparsely enhanced with gouache, was among the greatest paintings done in any technique. It was Holbein's influence that caused miniature portraiture of the sixteenth and seventeenth centuries to remain largely faithful to the watercolor medium. Dürer was the other great influence; and a few extraordinary watercolor drawings of towns and countrysides and admirable studies of flowers and birds have been preserved from the time he made his journey over the Alps and through Italy in 1490. Dürer achieved an expression of the intensity and the ephemeral nature of life, while revealing details invisible to the normal eye and impossible to translate in oils. He exploited the finest resources of the watercolor.

After Holbein and Dürer, watercolor appears to have suffered a kind of eclipse in Europe, difficult to understand even when one takes into account the troubled times and the difficulty of preserving anything as fragile as paintings on paper, as opposed to those executed on sturdier grounds. However, unknown watercolors are sometimes unearthed unexpectedly from archives where they have never been as systematically sought as other forms of art.

The situation during the reign of Louis XIV remained almost unchanged from the times of Charles IX and Henri III in the second half of the fifteenth century. Watercolors were used by miniaturists, decorators, architects, and all kinds of designers. However, Jacopo de Barbari, in Italy, and a large group of Flemish landscape and flower painters used the process systematically throughout the seventeenth century: Jordaens, Avercamp, Cuyp, Van Goyen, Van Ostade, Van Huysum, and Van Dyck. At that time the great master of this technique was Rubens, who heightened his extraordinary landscapes with watercolor and gouache. There was also an interesting and almost unrecognized French school—the naturalistic watercolorists—who painted serenely on through three centuries. One point of reference in this long history is a catalogue preserved in the British Museum entitled, *The Key to the Fields: How to Recognize Several Creatures, Animals and Birds with Some Flowers and Fruit.* It shows French watercolors and gouaches done by a French protestant, Jacques le Moyne de Morgues, who was a refugee in England and died there in 1588.

Fifty years later Gaston d'Orléans, son of Henri IV, employed painters at his court who were responsible for recording in gouache and watercolor the finest and rarest flowers in the garden he had created in Paris. This was the Jardin des Plantes, inherited by Louis XIV and renamed the Jardin du Roi.

The series of watercolors of the garden increased steadily from the early seventeenth century to the middle of the nineteenth. The beautiful books that have been preserved testify to the taste for painting flowers in aquarelle in France. The style is very different from the Flemish flower painters, and several artists deserve to be better known than they are. Also dating back to the seventeenth century are fans with historical and mythological scenes in miniature which reflect the tastes of the preceding century. Evidently watercolor at that time was a popular art, even though such paintings were seldom collected. Although only rare traces still remain, the beautiful work of the botanists Nicolas Robert and Aubriet, now in the library of the Muséum d'Histoire Naturelle, Paris, and the decorations of Cotelle in the Musée des Arts Décoratifs, testify to the originality and quality of the seventeenth-century French watercolorists.

Catalogues of exhibitions and of sales, as well as books and manuscripts written by collectors and artists record the reinstatement of watercolor painting during the eighteenth century. In 1722, Gillot, on the eve of his death, sent "some small *gouesse* figures" to a sale. This was the first time, to our knowledge, that a word was found to designate this long-existing technique. Mariette, a print dealer and a collector of drawings, a man with a lively mind, an enthusiast who was kept informed by his numerous acquaintances of all that went on in the world of European art and who was Secretary of the Academy of Painting, describes watercolor painting in several different ways. Unfortunately he did not date his notes, but we do know that he wrote the greater part between 1730 and his death in 1774. For a long time he did not use the words gouache or watercolor or wash in his discussions about watercolor painting. Speaking of Brueghel of Velours, he wrote: "Generally he did [his drawings] with a brush enhancing the foreground with *bistre* and using indigo for the more distant tones." Mariette did come near to one of these terms when, in discussing a certain Jean Chaufourier, a creator of landscape drawings and a contemporary of Watteau and Lancret, he said, "Sometimes his landscape drawings are lightly colored, using colors in water, and I have seen some that were well done and had considerable charm."

Mariette, while discussing a miniaturist, Jacques Antoine Arland, also speaks of a distemper. A definite change in the vocabulary appears toward the sixties. Guillaume Baur, a contemporary and imitator of the Flemish painter Elsheimer and to our minds a watercolorist, "succeeded," Mariette wrote, "in painting in *guazze* [gouache] miniature views of palaces and all kinds of subjects." And again he wrote that Baudouin, who died in 1769, "painted very pretty *guazze.*" Houel, too, he noted, "painted with *guazze* in Rome in 1770," while Van Huysum, a typical watercolor artist, according to Mariette, executed "studies of flowers colored lightly with watercolors." He goes on to say that in 1769 Clerisseau was made a member of the Academy for his "small works done in gouache," which

may well have been aquarelles, although the word, as far as we know, is a stranger to Mariette's vocabulary.

Grimm, and Diderot even more, used the terms gouache and aquarelle indiscriminately but they were still writing after the death of Mariette and, being journalists, they adopted the words used by painters in catalogues of exhibitions.

The catalogues of the exhibitions organized more or less regularly by the Royal Academy of Painting provide the safest chronology: in the exhibition of 1737 watercolor painting appears in the form of miniatures and possibly wash drawings. Before then, only oil colors had been shown. Drouais was the first miniaturist of the Salon, and he was still exhibiting in 1738, 1739, and 1740. From 1741 to 1743 there were certainly some drawings, but no longer any miniatures. On the other hand in the Salon of 1745, Boucher exhibited "a gouache sketch" of Venus rising from the foam. This work has since disappeared. Only fourteen years later, in 1759, Demachy exhibited "four drawings *à gouasse* after nature" and returned to the technique in 1763 with two more "*gouasses*." In that year Baudouin, Boucher's son-in-law, also exhibited a "*gouasse*." The catalogue of 1765 speaks of "*gouasse*" drawings by Demachy and small pictures—probably gouaches—by Baudouin. The following Salon, in 1767, sites small sketches and "several drawings colored after nature" by Hubert Robert (see page 51) and "several colored drawings" by Caresme. The same year also saw "drawings *à gouasse*" by Durameau, including *The Saltpeter Works* (page 47) and other works by Baudouin and Demachy. In 1769 "*guazze*" and "colored drawings" were again mentioned, and in 1773 Huet exhibited a gouache for the first time. In 1775 it was the turn of Hallé and Pérignon. In the Salon of 1776, beside the gouaches and watercolor drawings of Saint-Quentin, there appeared an "*aquarella*" by de Peters. The word is original and is supposed to describe a "new type of painting" which the same artist was to display and discuss under the name of "mixed aquarelle" in the Salon de la Correspondance, organized by Pahin de la Blancherie, a journalist, in 1779. The simple word, now so familiar, had made its appearance in the Salon two years earlier. According to the catalogue a painter of Flemish origin, Van Spaendonck, had exhibited "a bouquet of flowers painted on paper with aquarelle." Other exhibitors had shown "gouaches." In the Salon of 1780 there were only gouaches, but Van Spaendonck again exhibited watercolors of fruit and flowers in 1781. The following year Hubert Robert showed two watercolors in the Salon de la Correspondance, an unofficial exhibition. On April 24, 1783, the sale of the large collection belonging to Vassal de Saint-Hubert, the writer of the catalogue, lists several anonymous works under the description "drawings à la quarelle"; this word really has no standing now. Nevertheless in the Salon of the Academy in 1785 Van Spaendonck was still exhibiting his bouquets of flowers in watercolor, and in 1787 Lespinasse produced his admission piece to the Academy (see p. 59) painted "*à la gouasse et à l'aquarelle.*"

For the Salon of 1791 the Constituent Assembly decided to suppress the barrier of the jury. Painters not admitted to the Academy were now allowed to exhibit. There were watercolors by Monsiau, Lesueur, Baltard, Bourgeois, and gouaches by Louis-Gabriel and Jean-Michel Moreau, Mallet, Gadebois, Paris, and others. In 1793 exhibitors of watercolors included Genin, Bourgeois, Monsiau, Huvée, Lespinasse, and Thierry; gouaches by Mallet, Mondevard, Chasselat, and Gadebois. In the last Salon of the Convention in 1795 there were watercolors by Redouté the Elder, Redouté the Younger, Vernet, Gauthier, Genain, Liger, and Guérin, and gouaches also by Naudet, Drahonet, Dupuis, Percier, Fontaine, and Muris. In 1796 watercolor painters exhibiting for the first time included Berthon, Chancourtois, Lambert, and the new gouache painters, Mandevare and Antoine Martin. There were no new names in 1798 except Mongin and Georget, but in 1799 the gouache painters Châtillon, Lafontaine, Leroy and the watercolor painters Sergent Marceau, Jallier, and Génillon made their appearance. The official exhibition of 1800 marks the victory of watercolor painting; there were many works, many exhibitors, and a complete mastery of the technique of this art.

Although the descriptions in the official catalogues were vague, a sense of evolution can nevertheless be felt in the growing length of the lists. The period of the eighteenth-century watercolor is historically the second half of the century, or rather, after a tentative start under Louis XV, it came into its own in the reign of Louis XVI and the Revolution. The democratic and unofficial character of this technique is revealed by the prodigious invasion of watercolors in the Salon after non-Academicians received permission from the Constituent Assembly to exhibit. At that date the art of watercolor was already widespread, but fashionable painters found it lacking in dignity.

In the eighteenth century and earlier the great watercolorists outside France were English, German, and Flemish, but these artists had little influence on France. The artistic link between the Latin countries was so firm that the French and the Italians discovered and took up watercolor at the same time. *Acquarello, guazzo*: the words are Italian and were new even in the peninsula. They developed apparently when the scene painters of Venice and elsewhere, influenced by the Flemish and English, began to produce small watercolor landscapes, which sold very well. Although there was probably not much difference in the time between the discovery of watercolor painting in France and Italy, it is true that Durameau, Fragonard, and Hubert Robert brought back from their ultramontane journeys watercolor landscapes undoubtedly imitated from techniques they had seen used in Italy. These novelties were, however, combined with all kinds of very old French technical traditions: the miniature, the wash, the topographical plan or elevation, color-wash drawings for interior decoration, popular gouaches. The most original artists, who were constant in their practice of watercolor, such as Gabriel de Saint-Aubin and Louis Moreau, discovered a personal technique in which drawing, gouache, and

watercolor were used in turn or even simultaneously. It is the talent of the creative artist to adopt a new language, or transform an old, but such triumphs are beyond fashion, and history cannot explain them.

The history of the evolution of the watercolor in the eighteenth century lies written in the inventories of all existing works in public and private archives as far as these are known and catalogued. It would appear that none of the great painters produced watercolors during the reign of the Sun King or under Napoleon. When the mind of a century is too abstract, too absorbed by its hierarchies, it ignores the simple pleasures of life and despises watercolor as too spontaneous and too popular an occupation. No watercolors are attributed to Claude, Poussin, Lebrun, or Mignard. There is no doubt that neither of the two great landscape artists painted in the medium; after Claude and Poussin died in Italy, collectors disputed the most trivial things in their studios and the preliminary sketches of Louis XIV's two most important painters formed part of the Royal Collections. Many of these are now in the Louvre. This prejudice continued farther into the century. Neither Chardin nor Watteau, whose paintings on paper were miraculously preserved by devoted friends, ever used watercolor. Boucher may have occasionally painted in gouache, but to our knowledge there are none which can be attributed with certainty, and his studies are often oil sketches. The dominance of composition over effect, of idea over sentiment, strongly favored black-and-white drawing. Every premeditated work dispels the fugitive watercolor.

This situation was transformed by a reaction against the too intellectual approach of the Italians; by the victory of the colorists, led by the theorist Roger de Piles; and by the eventual triumph of the modern over the ancient. At the very beginning of the century watercolor came from Flanders and penetrated even the studios under the flag of the renewed prestige of Rubens, whose pupils also used watercolor. Painters returned to a more spontaneous realism under the influence of a great Flemish master established in Paris—Nicolas de Largillière.

His theories were admirably explained to the Academy by one of his pupils—Jean-Baptiste Oudry. Largillière recommended that landscapes and all ornament should be painted from life, and he insisted on a comparison of the finest shades of color. This appeal to feeling and spontaneity led to the use of watercolor. Largillière, however, was already teaching in the seventeenth century. The result of his advice is to be seen in the techniques employed by the two great animal painters of the Louis XV period: Desportes, who was almost contemporary with Largillière, painted even his most rapid sketches in oils; whereas whenever Oudry, pupil of the great portrait painter, wanted to catch the attitude of an animal or to record a landscape, he used watercolor.

Parallel to this revolution in the lofty circles of academic teaching a rapid transformation in public taste was taking place. Decorators were no longer, like the countless collaborators with Lebrun at Versailles or the Gobelins, merely craftsmen carrying out projects of the great painters. Late in the reign of Louis XIV a certain Jean Bérain devised new forms and drew models for tapestries and boats and decorations for the Royal Apartments without painting pictures first. However, one detail is typical: although Bérain did his drawings himself, he often handed them over to others to be colored. Color, and in consequence, watercolor, remained only of secondary importance. At the same period Bernard Picart and Claude Gillot were designing costumes and theatrical scenes, sometimes engraved, sometimes colored. Are they then inventors and decorators, or only chroniclers, illustrators of balls, amusements, and great spectacles? It is impossible to say, for to invent or recount was, after all, not so very different from taking part in such amusements. Watteau himself, despite his originality, was related to craftsmen painters and such was his philosophy; he is the recorder of balls and all the pleasures

of the *Régence*, but like Lautrec he transposed and refashioned what he saw. Watteau was slightly influenced by the Italian art discovered in the collections in Paris, but he never escaped into anecdotal facility. Nevertheless he learned his trade with Gillot, who was made an Academician before him with the description "painter of *fêtes galantes*"—along with Audran, in whose company he decorated the walls of the château of la Muette with Chinese scenes.

The success of Watteau, at once more realistic and more intellectual than all the great contemporary painters, produced developments in customs and taste that were very favorable to watercolor. The reception of Claude Gillot and other artists into the Salon marked an important step toward greater liberalism in academic painting, while the increase not only of pictures but of all painted decoration— on walls, furniture, and all kinds of everyday objects—offered new outlets. Never—except perhaps in the twentieth century—was the taste for pictures, representation of human beings, and familiar activities more lively than in the Louis XV period. Drawings and watercolors were the equivalent of photographs today, and the number of portraits multiplied enormously. Miniatures were frequently executed in gouache and watercolor. They were given away in many ways, and were often painted on boxes which were used for different purposes. In the reign of Louis XIV the richest furniture was decorated simply by pure line and form. In the eighteenth century a clavicord would be painted with ball scenes, and a carriage door with *singeries*. The marquetry of a secretary was occasionally replaced by delicate pictures done in *vernis Martin*, a technique flexible enough for any purpose. There were painted commodes; fire screens that were both paintings and functional objects. Small tables were sometimes decorated on all sides with watercolor landscapes made on paper and simply stuck on.

Many boxes were painted with scenes and landscapes designed to recall pleasant memories. For instance, Choiseul preserved at Chantelou a gouache by Blarenberghe on the sides of an exquisite box, a souvenir of his house and collections at the time of his ministry. The Prince de Ligne had a rather similar piece in his château of Belœil, on which he is to be seen with Marie Antoinette in the theater at Trianon. All these very small paintings were watercolors.

Eighteenth-century menus are very rare, but subtlety in the preparation and presentation of meals was clearly sought after. Some lists of food offered by Louis XV around the middle of the century to his guests in the castle at Choisy are painted in watercolor in a lively fashion, and, to honor the king who was so enamored of the hunt, are decorated with painted frames of animals and birds of the chase.

The programs for the great galas and spectacles were conceived in the same way. The painters of *Menus Plaisirs de Roi*—the office responsible for the entertainment of the king—(Jean-Michel Moreau was in charge during the reign of Louis XVI) designed costumes, and made colored plans of the *fêtes*

and worked them all out down to the last detail of projected firework displays. Later they also painted many watercolors as agreeable souvenirs for the most illustrious participants.

What do we know of the painted fans of the eighteenth century ? Only that very few good ones exist. Fans were used by every class of society and must have been a fine source of income for the aquarellists, because the decoration was nearly always painted. But they were fragile and easily broken. When at the end of the nineteenth century the Impressionists looked back for a link to the eighteenth century, Degas, Manet, Berthe Morisot, and Pissarro all painted fans in watercolor, though they were to be framed as decorations. The passion for pictures was even noticeable in men's costume : toward the end of the century coat buttons often had small watercolor scenes, landscapes or ruins ; these tiny miniatures were edged with copper and covered either with glass or transparent mica. The watercolor picture was one of the fragile luxuries of a society seeking the subtlest refinements.

Another characteristic typical of the eighteenth century and very propitious for watercolor painting was the equality between the sexes, the clear predominance of women in the social world and a greater difference than ever between masculine and feminine pursuits. The time was past when the Grande Mademoiselle could fire the canon of the Bastille or when the Duchesse de Longueville could emulate the glory of her brother the Grand Condé as head of a faction and the army.

Women of the Louis XV period were no longer Amazons. They impressed by their specifically feminine virtues. Art and technical skills were their province. The great mistresses, who have been accused of trying to run the state, were primarily women of art and letters. Both Madame de Pompadour and Marie Antoinette danced, played music, and painted. However, unlike Maria Leczinska, the somewhat unfeminine wife of Louis XV, they did not paint in oils, only watercolor, which was and still is a very practical feminine diversion.

The very reasons for the success of watercolor in the eighteenth century demonstrate its limitations. Circumstances aided its popularity, but there was no question of regarding it as an original technique or even as a new-found liberty. During the same period in England watercolor was becoming an independent art ; but it never appeared in France as such until the following century. The French amused themselves, experimented with processes, and simply colored ; the inspiration could be either a drawing or an engraving. The casual attitude toward color of Bérain's time can be laid at the door of Hubert Robert, whose personal technique was to draw and finish a scene before adding the colors. Eighteenth-century watercolors nearly always contain preparatory drawing, and frequently they are done over engraving, the richest, rarest, and most costly tones often being employed.

Never before had there been so much coloring. All the brilliant and extraordinarily varied uniforms of the regiments of France, or more often of the soldiers and officers of the Royal Guard, supplied

themes which were the more inexhaustible as the costumes changed—as they did more rapidly than ever after the third quarter of the century. Often gilding was done with real gold! Nor could anything have been more propitious for watercolor than the fashion magazine. Feminine clothes, which had altered only slowly over the centuries, suddenly began to change very quickly under the double impulse of a fashionable young queen surrounded by friends of the same mind, and the spread of journalism. Watercolorists were alone capable of rapid dissemination of the changes in female taste. Pictures of the mode, essential to women who wanted to know the Paris fashion, had to reach the provinces and the rest of Europe speedily, and they had to be reasonably clear. Sometimes they were drawings, more often engravings; in either case they were finely colored. Undoubtedly many unknown artists specialized in these charming pieces. The form remained—the picture was the same from one edition to the next—but the colors, greatly varied and always brilliant, were left to the free imagination of the watercolor artist; the illustrator of those days was free to invent rather than reproduce. This strange process, so fashionable in the reign of Louis XVI, of making charming drawings colored with varying tones, is typical of the intellectual climate of the day; perhaps the shining mirage of universal happiness, a necessary corollary to the rigid and theoretical ideas of liberty and equality which were the motive power of the Revolution, may be likened to these exquisite colors imprisoned within the rigidity of engraving.

After a period of slow development lasting sixty-five years, the eighteenth-century watercolor reached its apogee at the beginning of the reign of Louis XVI. That was the time when gouaches and watercolors in official and private exhibitions were sent to the Academy by members who no longer needed to paint professionally in oils to make a living. In 1787 Lespinasse became an Academician, and Jean-Michel Moreau became one in 1789. The suppression of the jury was an unexpectedly lucky event for watercolorists, and the number of painters using the medium increased annually.

The society of the time, so partial to pictures, was living through a period of intense ferment. Between 1789 and 1795 people in France felt that more decisive political events had taken place in five years than during the five preceding centuries. Fluctuating opinions gave the impression of a continuous ebb and flow, while some days in themselves must have seemed to have comprised several revolutions. Every Frenchman was both actor and spectator in the inflammatory drama; each knew that he was living through a period of carnage but was, at the same time, passionately interested in the harsh beauty of the events taking place before his eyes. Enthusiasm for the picturesque resulted in a craze for watercolor painting, not only for personal satisfaction but for a large international clientele hungry for historical souvenirs.

A prodigious number of watercolor scenes from the Revolutionary period exists. These records, just as precious as letters and memoirs, have been largely neglected by the historians—a great mistake

because these are notes made on the spot; scenes carefully and openly observed. They consist of Restif de la Bretonne's nocturnal descriptions done, as it were, by daylight and the works of Lallemand, Hilair, Debucourt, and Watteau de Lille, who sketched historical events against their actual background. What could be more evocative of the atmosphere of Paris and the phenomenon of the Revolution than the views of the Place Louis XV under the Terror, when the guillotine had been replaced by a menagerie and the Palais Royal and the boulevards were filled with a crowd that was both elegant and, despite the massacres, cheerful? These rapid sketches, so differently made from the slow elaboration of a great work of art in oils, represent the climax of French eighteenth-century watercolor.

The pleasant mirror in which a cheerful society smiled at its own reflection was soon to be shattered by a new generation of painters. David and other neoclassical artists no longer painted in watercolor, any more than Robespierre or Saint-Just framed their speeches in the style of Voltaire. Once again ideas and principles triumphed. A painter could no longer allow his mind free rein; he had to look for essential truths.

The only watercolors painted by David at this time were done in his capacity of decorator in charge of Revolutionary *fêtes*, and as designer of new costumes for the nation's representatives. His studies were drawn or painted in oils, and his pupils used the same system. Gros, Girodet, Ingres, Gérard are exclusively designers; like Poussin they aimed at style. A new society had come into being where the pleasant and agreeable things of life were not the sole criterion; an austere idealism had triumphed. When the watercolor came into fashion again, it was reborn in very intellectual form.

Eighteenth-century France was obsessed with idealism and glory from the time of Louis XIV to Napoleon, from Poussin to Ingres. The irony and pretended levity of the period should be viewed in the light of a liberation, and then as an equally difficult rear-guard action against the huge demands of the time. Between the battles of Malplaquet and Austerlitz, between *The Shepherds of Arcady* and *The Vow of Louis XIII*, between also *The Discourse on Method* and the *Critique of Pure Reason*, *Télémaque* and *Atala*, there was time for a smile. This smile was, in turn, mysterious and poetic in *Les Pélerins* by Watteau and *Les Prunes* by Chardin; it was cheerfully theatrical in the beautiful nymphs of Boucher; and sometimes it was openly simple, spontaneous, and sensual,—as in the child-women by Fragonard—before it became fixed on the charming face of Juliette Récamier, apparently ingenuous and seductive, but, in reality, frigid and inaccessible.

Determination, frenzied ambition, and a taste for sacrifice took their leave for a decade or two. A great effort was made to act one's part well: Louis XIV had sincerely believed he was the greatest king in the world, and his great-grandson, Louis XV, clung conscientiously, and with some skill, to the same role, which bored him and in which he no longer believed. It was a period of rejection of humanism. One is condemned to a total incomprehension of the heroes, writers, and artists of the French eighteenth century if one tries to judge their conduct according to the rational and pragmatic criteria of today. Voltaire, Rousseau, like Fragonard or David, are not really incoherent, but spontaneous and not in the least embarassed by their successive changes of heart. Eighteenth-century society as a whole lived out the paradoxical life of an actor; the perpetual comedy was played by everyone—kings, philosophers, artists, down to the smallest landowners.

The irritating seductiveness of the best works of art at the end of the period arises from their unfailing ambiguity. And actual characters, such as Valmont and Voltaire, are equally difficult to analyze. Are they good or are they wicked ? In the midst of the worst depravity Valmont saved a peasant, without apparent reason, from ruin. As Marivaux so aptly said of Voltaire : he has all the vices, even that of being occasionally virtuous. No one at that period was altogether above reproach. The character and politics of Louis XV and Louis XVI have been infinitely and vainly examined. Fundamentally very different, the two kings were equally devoid of energy and equally incapable of governing. It was an age when women seemed like flowers and men birds of Paradise. In *The Marionettes at Saint-Cloud*, Fragonard blends all his characters in a leafy park where gay and elegant clothes are the complement to the beauties of the garden. The psychological analyses of classical tradition were succeeded by imaginative portraits. A sparkling glance and a ruff in the style of Henri III, but above all a determination not to be too interested in the life of the soul, made seductive symbols of Fragonard's friends and contemporaries. Everything—from the heroic to the comic—is rendered equally pleasant. A disturbing innocence belongs to the eighteenth century. It is the characteristic charm of watercolors in France at that time : a succession of apparently quite simple images which attract, seduce, interest, and disturb.

The art of candor and of transparency offers opportunities not found in any other pictorial technique. With no *impasto*, and with color resources limited by the brilliance of the white paper and the impossibility of superimposing tones, watercolor rediscovers depth and distance, the light of the open air, and everything that is simple and available in nature. It issues from one of the most deep-seated and characteristic tendencies of the eighteenth century. And the method, now out of style, pleased the people of that period.

The free engraving, the pastoral painting, the landscape with ruins, are exacting themes to which only watercolor can do real justice. The whiteness and transparency sustain a true lightness, which gives a tone of fantasy and unreality to the daring scene. There is a great difference between the romantic English or French landscape. The eighteenth century in France was truthful without being exact. It was Delacroix, following the English, who was to be the precursor in watercolor of the realistic claims later made by Impressionism. But when Fragonard paints a watercolor of an unmade bed—the perennial subject of an age of *liaisons dangereuses*—he has no need to include the protagonists ; everyone can easily imagine them and maliciously invent any number of small amours, for is not the imagination in some cases capable of evoking a reality more powerful than that of the material world ?

The work of Hubert Robert also leaves much to the imagination. He was not concerned with making a faithful reproduction of picturesque ruins. Poetry is born, not of a photographic reproduction, but of the contrast between the dead stones of ruined empires and the fresh youthfulness of the washerwomen.

What are the ruins ? Who are the washerwomen ? It does not matter. Even the observant eye of Saint-Aubin is prey to inaccuracies. He paints an atmosphere. We do not see the pictures at the auction sale or the articles offered in a fashionable shop, but only the impression these strange spectacles make on us. A watercolor, by definition, is never finished, for it is painted quickly and white areas are left —purposely. While he works, the watercolorist always has chance at his elbow ; he applies a liquid to the paper with the brush without being able to determine precisely the outline of the applied tone, or the exact color, which is influenced by the ground and by the medium. No corrections are possible afterward without using different methods, such as drawing or gouache. Exposure to the light helps to soften the harsher colors and, in consequence, to create a new harmony and unity. This bouquet, this touching patina can never be removed. Stripped of its varnish and strongly lit, an oil painting can recover its primitive brilliance, or at least give the illusion of having done so. The changes that take place in a watercolor are irreversible ; it has the charm, intensity, and fragility of a beautiful memory.

The advantage that watercolor painting always has over oil painting is that it is quick and can be used at all times for recording an image of a scene on the spot. Unlike oils, watercolors never become immutable objects. When Hubert Robert paints imaginary gardens and theaters it is with a light heart, and so it is with the theater costumes and sets imagined by Boquet, Michel Moreau, Gillot, and Bérain. Watercolor is an ideal technique for the play of colors : nothing heavy, nothing precise ; but brilliant, light, and transparent colors, suited to the painting of dreams.

As the Encyclopedia explains, watercolor painting is the method chosen by landscape artists who paint *sur le motif*. Until the middle of the nineteenth century there were no tubes of color, neither oil nor gouache. The first appeared toward 1840, the second about 1850, and the importance of this technical progress has often been justly emphasized in discussions of the history of French landscape painting from the Barbizon school to the Impressionists. But by ignoring the watercolorists of the eighteenth century one neglects the antecedents of this movement and wrongly defines the renaissance of tradition as a revolution. Clearly Louis Moreau was not the first open-air painter, but, in company with other contemporary watercolorists, he allowed himself to be inspired by the moment, immersing himself in the landscape and renouncing the rules of perspective and the requirements of a fine composition. He abandoned himself to the emotions produced by blue sky, the grass, or shining sun. A solitary walker, he could be seen habitually in the countryside and gardens near Paris, and was as enthusiastic as Jean-Jacques for everything he saw. Moreau's work has nothing in common with the historical and mythological landscapes of former times, nothing with the Flemish or Dutch peasant paintings ; everything he painted is simple, spontaneous, fresh. His small gouaches or watercolors are as far from the traditional landscapes as are the letters of Voltaire from his tragedies : rapid sketches, seductive, evocative, and

sometimes insincere. In the nineteenth century the Impressionists painted exactly what they saw, but realism had become a religion. In the eighteenth century, when sometimes even bishops were unbelievers, the landscape artists were not slaves of nature; the lie, the inexactitude, a certain deceit were the necessary seasoning of painting as of conversation. One can never have absolute confidence in either Moreau, Robert, or Demachy. Trees disappear, buildings increase or decrease in size. The truth lies in the atmosphere, the inspiration of the work. Every artist expresses himself after his own fashion and sincerely paints his instant reaction.

No other period has left such a complete picture of itself, or one that is so difficult to understand. The seventeenth and nineteenth centuries made great claim to truth, and are therefore represented solely as they would like to have been, rather than as they were. The eighteenth century painted its vices, which it felt were just as agreeable as its virtues, and this is why it is considered to be completely immoral. The art of that period was not by its own standards immodest, definitions of modesty being very different then from what they are today. Painters and the public of the eighteenth century were interested in every subject as long as it was pleasant. Only ugliness was considered immoral. There were no social or physical taboos. Under Louis XIV and Monsieur Fallières nudes were nymphs, and neither peasants nor workers ever appeared in art. The wretched farmers of a realistic painter such as Le Nain make music and drink their wine from crystal glass like the aristocracy. The winegrowers of the naturalistic painter Courbet are dressed in their Sunday clothes.

The absence of scruples and ambition among watercolorists of the Louis XV period produced pictures that were more spontaneous and sincere. Watercolors tell us a great deal about the customs of those days, but false modesty today is such that these small masterpieces, engraved in series in a reign universally condemned for its absolutism, have never been published in the middle of the twentieth century; it is still not possible to describe or reproduce them. Yet the cinema and the press use pictures that are equally licentious and in no way transmuted by art. Today exhibitionism is tolerated and poetry censured. In the eighteenth century the contrary was true; the role of art was to transfigure, to render poses and situations of the most indelicate nature charming or witty. Every mistress was pretty, every lover charming. Can that be regarded as dishonest ? The painters saw through the eyes of a lover.

The poorest part of the French nation and at the same time by far the most numerous, ignored by the classical monarchy and the bourgeois republic, nevertheless appears in eighteenth-century watercolors. There the itinerant merchants of Paris, whose picturesque rags were as fashionable as the characteristic cries which they emitted —water-sellers, stove-setters, fishmongers, flower-sellers and so on —all drew the eyes of Lallemand, Demachy, and Hilair. Owners of performing dogs or monkeys and wandering players were often depicted, and without hyperbole. They were poorly clothed and appealed only to a very limited public. Lépicié and Durameau were interested in workers, which was rather exceptional even a hundred years later when socialism appeared. The countryside appealed far more, and one often sees paintings of those same peasants who were to burn down the châteaux before embarking on the conquest of Europe in the armies of the Revolution and the Empire. Some are barefoot; but this is rare, and their clothes are generally simple and decent. All of which agrees more or less with the descriptions of contemporary foreigners. There were many beautiful interiors painted by Lavreince, van Blarenberghe, and Mallet; some were very ornate, others quite modest. They are usually paintings of noble and bourgeois houses, which we can no longer recognize. Their very abundance offers a panorama of family life, showing us room after room, and discovering all the different kinds of furniture and decoration. One recognizes here the exaggerated taste of this egotistical period for the image created of itself. To show a photograph of one's drawing room or country house is not considered good taste today.

Formerly just as one offered his portrait in a ring or locket, as a small oil painting, or full-length or in an engraving, people often commissioned watercolors for themselves or for others of the places that they had arranged or visited.

There are many ways of evading reality. Dislike of oneself can lead one to look at other and sometimes surprising objects, and to invent new images and distant places to escape to in one's mind. The fever of self-love leads to an idealization of the human figure and its background. The history of art is full of examples of the two alternatives of nonfigurative pessimism and academic hyperbole. It is rare for the simple pleasure of being alive, the sense of wonder at the world to be the whole inspiration of poets and painters. The success of Impressionism is that it offered the last aspect of innocence, the last portrait of happiness. There have been *danses macabres*, martyrs, saints, and idyllic or terrifying visions of the Last Judgment; heroic cavalcades of conquering kings, deified or wearing a Roman toga; followed by the great historical or mythological compositions of the romantic painters. Poussin, Delacroix, Ingres, Lebrun, and other artists shared the conviction of the Middle Ages that the simple spectacle of the street or the fields was unworthy of their art and that truth was to be sought somewhere beyond the beautiful bosom and charming face.

The eighteenth century was one of those rare periods when the conception of original sin was largely ignored. The rise in the standard of living in several classes of society was so rapid, the progress in the arts and sciences so promising, the spirit of tolerance so general and existence for nobles and bourgeois so interesting, so subtle, so sweet, that it did not seem too Utopian to believe that all the inhabitants of France could, by means of a few reforms or a peaceful revolution, reach, if not an earthly paradise, at least a very acceptable substitute. All the beauty and joy of the world were in full view. It was not necessary to turn princesses into goddesses: Diana and Venus were given the grace of a peasant. The most bourgeois country fair; the *fête* held at Saint-Cloud, where the whole of Paris converged every autumn (it was a kind of royal fair held beneath the shade of great trees) took on the air of a Parnassian apotheosis. The period never grew tired of watching itself, or of going into ecstasies over its own charms. A smiling narcissism characterizes the paintings of Chardin and those of Fragonard in the same way as the writings of Voltaire and Rousseau. To look at oneself was to admire. The painters made portraits of themselves, their friends, their town, garden, or kitchen without restraint and with perfect self-satisfaction.

No subject was thought too bad for a painting in the eighteenth century. No interior of a factory repelled Durameau, no customs office was too austere for Lépicié, no road laborers unworthy of Demachy, no empty and unmade bed an insufficient pretext for Fragonard. This period, reputedly so aristocratic, certainly had no sense of hierarchy: any theme was suitable. And realism never had the

artificial sense given to it by the nineteenth century, there was only one approach: to discover the charm of people and things. In a hundred, two hundred years the situation had remained much the same. The women were no less beautiful, nor the countryside less picturesque, but the observer had a different eye. Many still-life painters before Chardin had painted fruit or fish, but they were always more carefully composed and more idealized. No one had had the calm audacity to look for beauty on the kitchen table. Gabriel de Saint-Aubin, who was of the same mind, went everywhere with his sketch book: to an auction, to a fashion merchant, to the review held on the plain of Sablons, or into the courtyard of a university. Every such scene is interesting, pathetic, seductive, as though one were present at a decisive moment of history. The pictorial genius lies in making the milliner Mlle Saint-Quentin and the awkward Comte de Provence fascinating heroes—and perhaps in a way they were? There was no ambition to look for eternal truths through the scenes of daily life. Mallet and Lavreince were excellent reporters but were not interested in philosophy. They were exact, faithful, and content.

Eighteenth-century watercolors are the result of a miracle: at that time artists only painted what they saw, and everything they saw was admirable. Such a perfect sense of balance could not continue. A society cannot be satisfied with contemplating its own image for long, indeed in this case it was too sure of its strength and beauty to fear any improvement. And this dream of an even sweeter, more beautiful France was to be the cause of the Revolutionary cataclysm, despotism, fear, denunciation, death; twenty years of war and massacre in the name of glory, liberty, and the nation—as if a flower or a smile were not more moving than the sun of Austerlitz.

Amateur painting is one of the most mysterious manifestations in the history of art. Such paintings are innumerable and universally regarded as banal, and are left to decay. A talent which admits to being a diversion scarcely excites the curiosity of the historian. It is well known that in the eighteenth century as in the seventeenth, it was usual for a noble or bourgeois young lady to paint as well as to sing, to write, or to take part in plays. Oil colors were expensive and complicated, whereas drawing and watercolor, then as now, were by far the most practical methods for the amateur.

The daughter of the Empress Maria Theresa, born into a family where everyone was devoted to the arts, drew and painted watercolors and gouaches, some of which can still be seen at Schönbrunn. Marie Antoinette, wife of Louis XVI and the youngest daughter of the House of Austria, continued to paint for amusement at Versailles and Trianon and she possessed a large box, a present from her mother, decorated with watercolor views of her native city. The box contained all that was needed both for sewing and painting. And when her numerous biographers hardly bother to mention this pastime of the queen it is because there seemed to be nothing exceptional about it at the time. In any case no one saved these royal works, perhaps for the reason that among the many more or less authentic

souvenirs that have been preserved, it has never been possible to identify with certainty a single water-color done by the last Queen of France. But one witness, an habitué of the court, the Comte Paroy, unwittingly shows us how little importance was given to the work of an amateur watercolorist, even that of the Queen herself.

"The Queen used to honor with her presence the late evening receptions held in Mme. de Polignac's— or rather M. le Dauphin's—apartments, for she was his governess. One day Her Majesty brought a watercolor sketch she had done in the grounds of Trianon and, leaving it on a table with her paintbox, went to play a game of backgammon with the Princess de Lamballe and the Baron de Vioménil. I took advantage of her absence to borrow the paintbox and went into Mme. de Polignac's study. There I set to and quickly embellished the view with a scene I had witnessed at the same spot. It had happened several days previously when the Queen was out after dinner at Trianon to see how her orders there were progressing. She was standing beside a gardener who was pushing turf in a wheelbarrow; she remarked that she would like to be able to say she had worked on her own garden and took the wheel-barrow from the hands of the gardener and started to push it, but she had not realized that the ground was sloping and the barrow, going too fast, pulled her along. The Queen, laughing, had to let it go. Several of us were following and ran to help. The Duc de Villequier got there first and solemnly said he was afraid she might have fallen, which only caused the Queen to laugh more."

"Since the drawing was a view of that particular slope, I quickly painted in the scene of the Queen laughingly dropping the wheelbarrow, with the Duc de Villequier standing talking to her. The Duc was easy to recognize, small with large shoulders and a short neck. He could be picked out too by his dress, as the other figures were only small sketches done in six or seven lines. It only took two hours. After her game of backgammon the Queen went on to play billiards in a neighboring room, so I was able to put back the drawing unobserved in her box and Mme. de Polignac sent it back to the Queen.

"Next day Mme. de Polignac's valet appeared before me in Paris with a message that I was not to fail to be at Versailles before ten. I was there punctually.

" 'Cousin,' said Mme. de Polignac seriously, 'the Queen is furious that you have taken the liberty of adding figures to her drawing. She has instructed me to tell you so and to forbid you to appear in her presence. So from now on you must not be here at any of the times when she is accustomed to come.'

" 'That is impossible,' I said, 'from all I know of the Queen. I am sure that she must have been amused to see the scene with the wheelbarrow, which made everyone laugh so much, added to her drawing, and besides, no one except Her Majesty, you, and I could know that it was not she who had painted the whole thing. She may be sure of my discretion.'

" 'You are right,' replied Mme. de Polignac. 'Yesterday evening the Queen sent for me and showed me her drawing, which had had no figures in it when I first saw it. She had inquired among her ladies-in-waiting and none of them was able to say how anyone might have touched the drawing, so she asked me whether I knew anyone who could have done it. I thought of you at once, but hesitated to give your name, so the Queen said in a kindly way, "But tell me; I am not angry, I think the empty space in the foreground has been excellently filled in, and I was able to recognize the Duc de Villequier from his clothes, and Mme. la Comtesse Diane." '

" 'Well then, Madame, I will tell your Majesty that I believe one of my cousins, the Comte Paroy, who is a painter, to be guilty; it can only have been he.'

" 'Then you must find out and tell him I am extremely angry. Don't forget. Speak to him very severely, although really I think he has done it well and I was pleased when I saw it. I do not want him to talk about it. Tell him so.'

" 'So, you see, cousin, I am telling you the whole story. I sent for you early so as to tell you; stay and take luncheon with me; I think the Queen will not be long in coming, but remember to look very contrite.'

"About noon the Queen arrived while Mme. de Polignac was writing and I was examining a large folio of prints of Swiss views. I got up and retired to a corner by the window; the Queen as she passed looked at me severely and went straight to Mme. de Polignac and asked if she had spoken to me.

" 'Yes,' she said, 'and he replied that it did not occur to him that he might offend Your Majesty.'

" 'Of that I am sure,' the Queen went on, 'Call him.'

"Mme. de Polignac signaled for me to approach. I did so with a respectful and deferential air.

" 'You draw very well,' the Queen said, smiling. 'You proved it yesterday on my little sketch.'

" 'Madame,' I replied, 'I saw the scene which made you laugh and I thought perhaps it would not be a bad idea to have a painted souvenir of the place where it happened.'

" 'Mme. de Polignac has been very harsh, has she not ?'

" 'She did as she was bid, but I had great confidence in Your Majesty's kindness in realizing that I only intended to give pleasure.'

" 'It was a good idea; I shall send the drawing to my sister in Brussels; I am sure she will like it. I would like to show you several other paintings I am sending to her.' The Queen sent for them and I told her that I was familiar with that kind of subject and had made a special study of them.

" 'Very good,' the Queen replied, 'I have several in mind, I will give them to you and shall be pleased to have your ideas about them.'

"I replied that I was happy and honored that my talent appealed to her. The Queen gave me about a dozen at different times. She was pleased with the way I carried out her commands and sent several of them to her sister the Archduchess, whom she dearly loved."

For both Paroy and Marie Antoinette watercolor painting was an inconsequential pastime, according well with the brilliant diversions which society invented to subjugate and divert the dangerous and menacing future. The collection of the Queen's sister, the Archduchess Marie Christine, wife of Albert of Saxe-Teschen, is preserved today in the Albertina in Vienna. But the painting of the wheelbarrow episode is not there.

The purity of the water, brilliance of the air, and whiteness of the paper combine to lend a special virtue to watercolor. This art possesses an almost pristine moral quality. Early watercolors are synonymous with freshness, naïveté, and sincerity. But transparency seems to restore everything to its proper perspective, conferring on a watercolor an uncertain, indefinable appearance which calls its very existence into question. The blue of the sky is as transparent as the moment when we, like an indefinable figure in the distance, resemble a person whose character remains hidden until he dies.

Ideas alone can confer on people or objects the stability of clearcut reality, certain, reassuring. Neither opacity nor the geometrical line exist in nature, nor does one find flat monochromes or isolated objects. But we most easily recognize our universe when it is arbitrarily delimited and schematically colored. Although we recognize the artificial nature of this conceptual reality, it corresponds to words, signs, memories, and conventions, and we do not easily accept anything else. We are too lazy to look for the truth and too fixed in our attachment to the convenient falsehood.

The eighteenth century was a privileged time, a moment when an element of doubt entered into painting. Of course the subjects of fine art were still historical, mythological, and religious, but even the finest traditional themes became only pretexts : no one believed entirely in them any longer. The artists were materialistic ; an attractive nude, a bouquet of flowers, the woods and fields were more to their taste. They always tried, however, to look beyond, for the material world presented nothing more than a marvelously successful backcloth. One or two generations hung in the balance between the medieval religious ideas of a supernatural world and the positivism of the realists of the nineteenth and twentieth centuries. People stood questioning. With a naïve absence of prejudice man pondered the universe, and his answer was candid. Painters observed a face or the sky with the respect and passion accorded to an ultimate reality ; they well knew that the whole mystery of the world is present in the smallest object, for although few were religious, everyone still believed in God.

In its painting, the eighteenth century is not therefore so much unbelieving as receptive. The cult of saints and kings had turned artists' attention away from daily realities for years, while the advance of science had still not convinced them of the absolute value of appearances. This doubt was the genius of the watercolor painters of the time. Despite the extreme inequality of their talents no one can deny their almost universal qualities of spontaneity, liberty, freshness, unknown at other times, which are the distinctive marks of their superiority. Having escaped from rigid intellectual dogmatism, people no longer felt always obliged to aim so high, or to inspire noble sentiments, to represent and to choose beautiful subjects ; the superstitions of a positivist age did not constitute for them an irrefutable aesthetic belief : photography is still not considered as the ultimate in dimensional truth, nor was painting then a means of attaining a metaphysical absolute. The eighteenth century was a moment of true liberty.

Antier and Mallet, Fragonard and Robert, Moreau and Saint-Aubin, like Restif, Rousseau, Voltaire, Laclos, Montesquieu, Rivarol, and Diderot, saw with their own eyes, questioned everything unceasingly, and smilingly retained a certain detachment. With serenity and precision they painted the most indefinable and evanescent reality. They scrutinized and observed and were moved to cry with André Chénier :

"Farewell, O Tomb of Flesh, I am no longer yours !"

THE ARTISTS

V. Antier: *Place Vendôme, the Capuchin Convent, and the Boulevard* (1706). Gouache on paper, 13×21⅝ in. (detail). Signed: *V. Antier 1706.* Musée Carnavalet, Paris.

At the beginning of the eighteenth century watercolor painting was not recognized as an art in France. It was a popular or utilitarian means of expression. The name of Antier, three of whose excellent gouache views of Paris now hang in the Musée Carnavalet, is not mentioned in the records of the period. Undoubtedly, he was a "maker" of urban landscapes, an artisan who made paintings of the monuments of the capital for his bourgeois clientele—commercial pictures rather like the postcards sold to tourists today. At the time this gouache was done, the first buildings were going up in the Place Louis-le-Grand, now the Place Vendôme. The spontaneous, sincere realism and careful observation of both town and country constitute the charm of a somewhat arbitrarily colored gouache, which surely made no claim to be a work of art at the time it was created. The buildings of a large monastery stand in the middle ground, and part of its grounds had been purchased to make space for the new square being built to honor Louis XIV. Where the Capuchin convent once stood, a whole district of Paris was developed much later in a triangle bounded by the Place Vendôme, the Avenue de l'Opéra, and the Boulevard des Capucines. In the distance one can see the hill of Montmartre with its windmills.

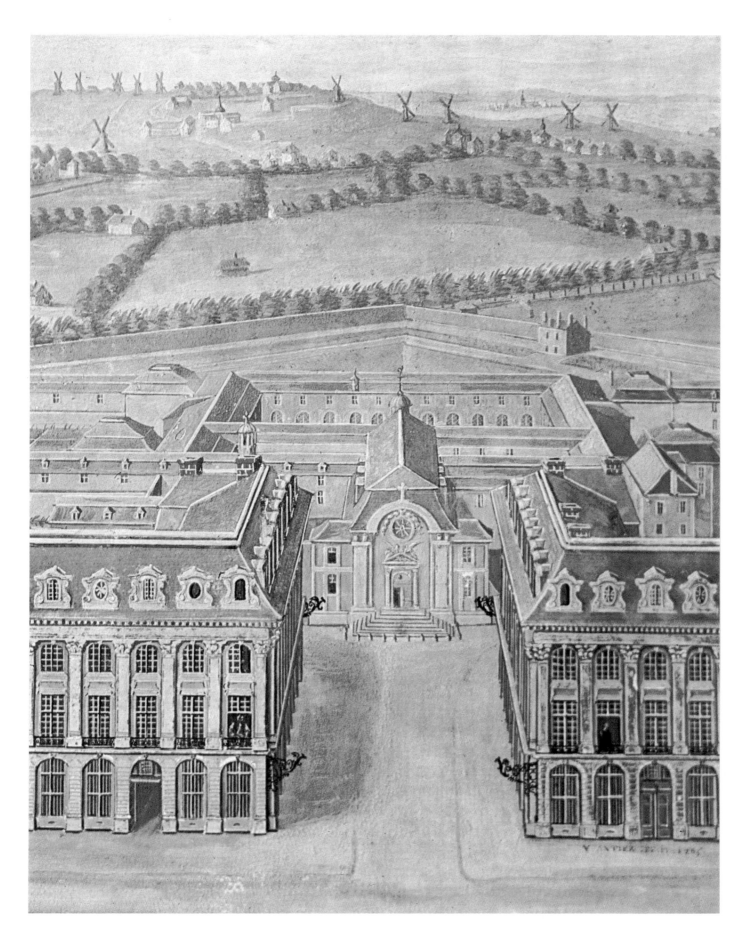

Claude Gillot: *Incident with Coaches*. Red chalk and wash on paper, $6\,^1/_4 \times 7\,^7/_8$ in. Private collection.

Toward the end of the reign of Louis XIV, and in the early part of that of his great-grandson, there were a great many inventions, discoveries, and changes. Many new political, philosophical, economic, and artistic ideas, too far in advance of their time, faded away only to reappear in the second half of the century. Claude Gillot was undoubtedly one of the painters who led an important revolution. At a period when only religion, mythology, and the portrait seemed worthy of the attention of great painters, he was sketching scenes in the street or the theater. When all the fashionable artists were employing oil and line exclusively, he used watercolor. Nevertheless he was elected to the Academy, and trained the young Watteau in his studio. At once an artist and craftsman, and somewhat bohemian in his style of living, Gillot probably did not follow any very rigid principles. He liked to blend wash and watercolor to enliven a drawing in the same way that he, and later Watteau, blended the theater with everyday life. Thus, during the first few years of the eighteenth century, Gillot was using watercolor to record events in a way used again several decades later. Between the eras of Gillot and Fragonard, watercolor suffered an eclipse. The idealized, intellectual art of Coypel or Nattier and their contemporaries was really not compatible with a simple process designed to express spontaneous reactions.

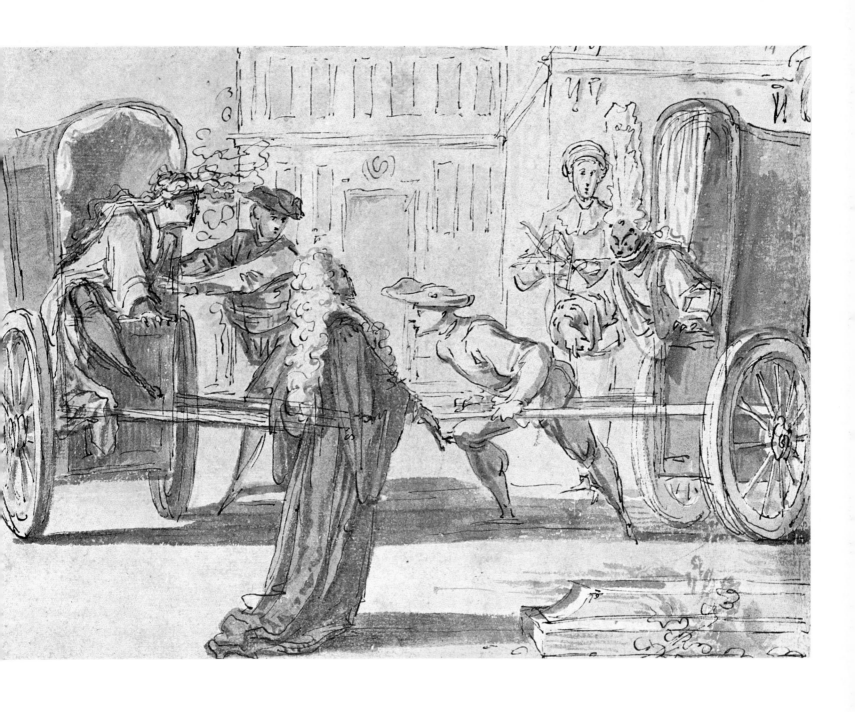

Augustin de Saint-Aubin : *The Saint-Cloud Ball*. Bister and watercolor on paper, $7^7/_8 \times 5^7/_8$ in. Musée du Louvre, Paris.

The French have always loved festivals, but the eighteenth century marks a turning point in society's idea of how such things should be done: *fêtes* were generally *champêtres*—out of doors and in a rural setting, as one can see from the pictures of Troy or Watteau, in which dancers and musicians disport themselves in parks or woods which become less and less ready to receive them. These gatherings were gradually thrown open to everyone, so much so that by the end of the century high-ranking noblemen and the Queen herself attended balls where they mixed with the modest bourgeoisie, and even the proletariat. The balls held at Saint-Cloud contributed greatly to this development. The castle, built by Philippe, Duc d'Orléans, brother to Louis XIV, was quite near the capital. From Paris it could easily be reached in a few hours on foot, or more conveniently by boat, for the Seine encircled the end of the park. As it was on the road from Paris to Versailles, Saint-Cloud was very well placed for receiving the court. In the autumn every year a great *fête* was held. Wrestlers, acrobats, and musicians entertained, and there was dancing in the garden. Many Parisians went there, brushing shoulders with the highest aristocracy. The Dukes of Orléans used the occasion to heighten their popularity, and during the minority of Louis XV, one of them, the Regent, Philippe, had shown how the search for pleasure could become one of the dedicated aims of human existence. Toward the end of the *ancien régime* his great-grandson, nicknamed Philippe Egalité during the Revolution, organized other gatherings in the Palais-Royal, where he participated in the first popular revolts. Augustin de Saint-Aubin, describing the autumn *fête* at Saint-Cloud toward the close of Louis XV's reign, still wavered between drawing and watercolor. But the sepia tones heightened with yellow and brown vividly evoke fading leaves and September light.

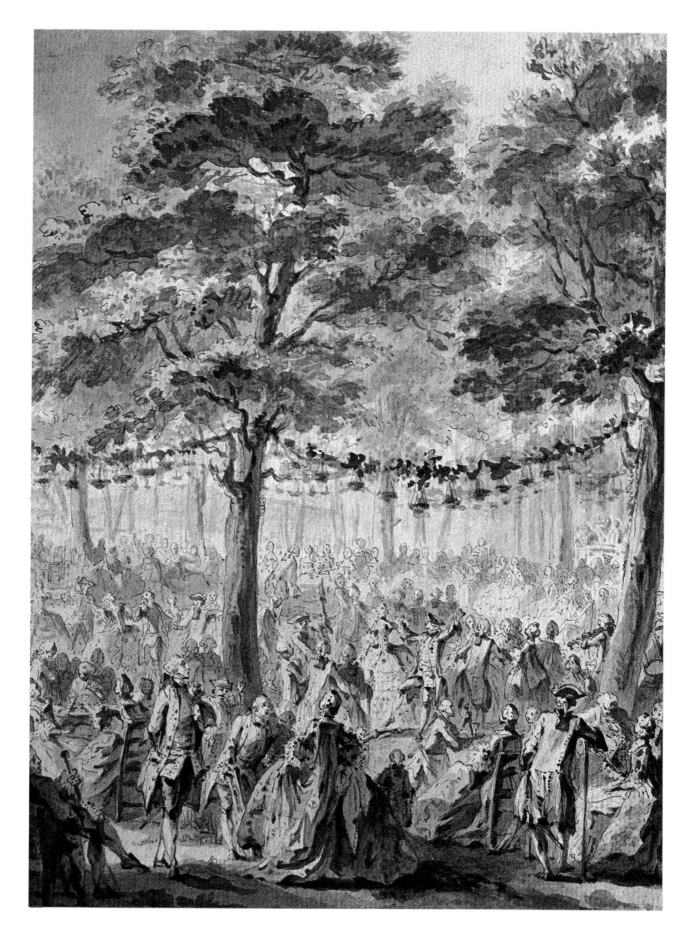

Jacques Charlier: *Cupid Beseeching Venus to Discard Her Sash*. Gouache on oval paper, $16\,^1/_8 \times 12\,^5/_8$ in. (detail). Private collection.

Mythology occupies an important position in French painting of the eighteenth century, but its role is in many ways equivocal. In the reign of Louis XV pagan religion had lost the fascination which had beguiled the Renaissance. As in the seventeenth century, deifying kings and lesser nobles remained a fashionable exercise which often took on the aspect of a game. However, the taste for simplifying, generalizing, and idealizing continued, and mythology offered a rich mine of symbols. Also, the expression of sensuality had to be disguised. A painter would not have dared to exhibit a nude in an official exhibition, but in a historic (and therefore noble) painting he could present a seductive model if she appeared under the guise of Diana or Venus. Jacques Charlier was a painter of nudes who pretended to use only mythological subjects in order to satisfy the whims of his clients. It was a skillful, subtle, and affected art. Gouache allowed him to do a greater number of small paintings more cheaply than large oils. Charlier's mythological themes, reminiscent of the lost gouaches of Boucher, mark a precise stage in the evolution of taste between 1750 and 1770, and were an appropriate ornament for the small, low-ceilinged apartments becoming fashionable at the time.

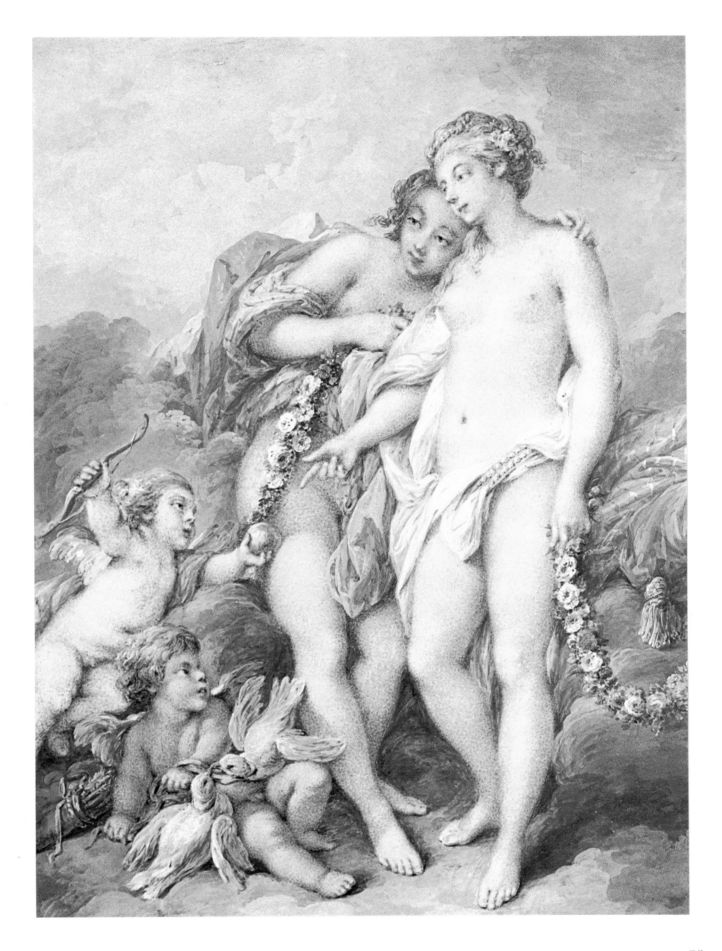

35

Pierre-Antoine Baudouin : *The Cherry-Pickers* (about 1765). Gouache on paper, $16^1/_4 \times 7^7/_8$ in. Private collection.

The peasants, described by a writer in the Louis XIV period as wretched beasts, play the role of idyllically happy human beings in eighteenth-century paintings. Pierre-Antoine Baudouin usually portrayed the artificialities and refinements of society. In contrast, peasant life was used to symbolize simplicity and innocence. At the time when Baudouin was painting, Rousseau was writing *Le Devin du Village* and *Emile*. Love of nature was a common theme of art. Baudouin, however, who can scarcely ever have left either his studio or his own town, was a painter who was less happy with landscape than with interiors. He painted leaves and trees as he would furniture and curtains. He did not even try to distinguish between plants and manufactured objects. But the theatrical and static character of the composition should not deter us from recognizing the originality of this outdoor gouache. Louis Moreau and other watercolorists undoubtedly attained greater reality, but Baudouin led the way in landscape painting.

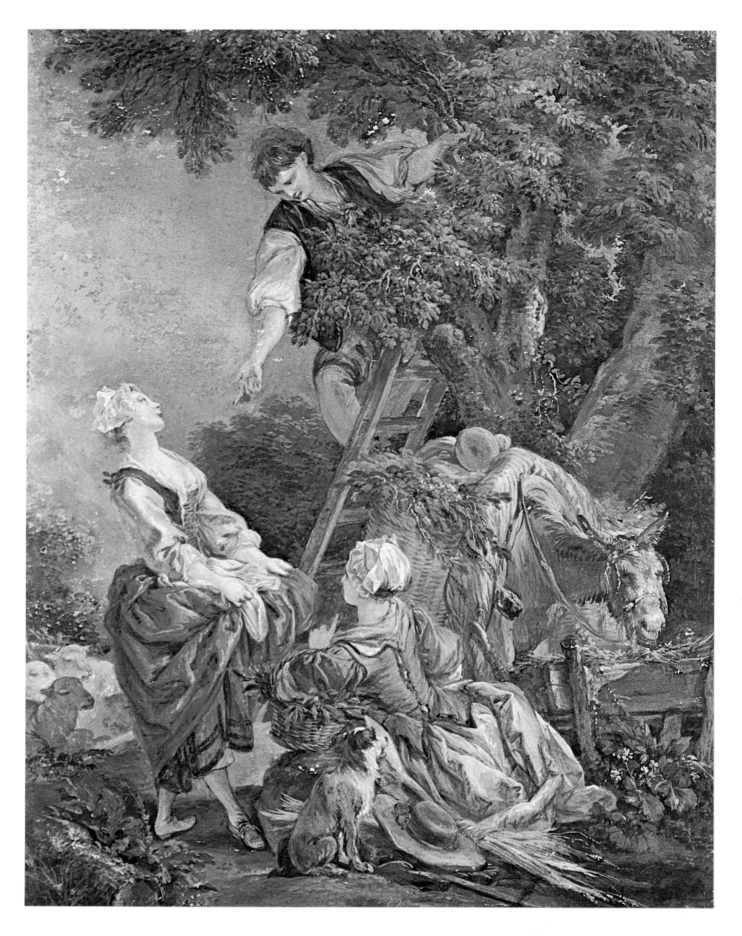

Jean Pillement : *Design for a Chinese Decoration.* Pencil drawing and watercolor on paper, $13^3/_4 \times 17^3/_4$ in. (detail). Private collection.

During the whole of the eighteenth century the only exoticism in France was inspired by China, and the only real alternative to French philosophy and conventions was found in Oriental civilization. The themes of primitive man, of the noble savage of America or Africa, were indeed exploited in literature by Rousseau's disciples, but they found no kind of pictorial expression till the nineteenth century. Despite the distance between them, the decorative arts in China and in France were closer than they are today : Chinese porcelain was used on the tables of the nobility, and pottery objects were imported and mounted in ormolu; commodes and furniture of all kinds were sent to China to be lacquered; the asymmetrical garden with unexpected vistas was first called a Chinese garden, before it became known as an English garden. The walls of a house or a reception room were often decorated with Chinese papers. At the beginning of the century artists painted the walls themselves in oils. In the reign of Louis XIV, when light, temporary decoration was the fashion, the use of printed papers and wall-hangings became popular. Often papers were painted in watercolor from a small model done by a fashionable artist. Jean Pillement, who was interested in all kinds of decoration, demonstrated here an idea for a Chinese wall-hanging; its varied and luxuriant vegetation must have transformed the room where it was hung into an exotic garden.

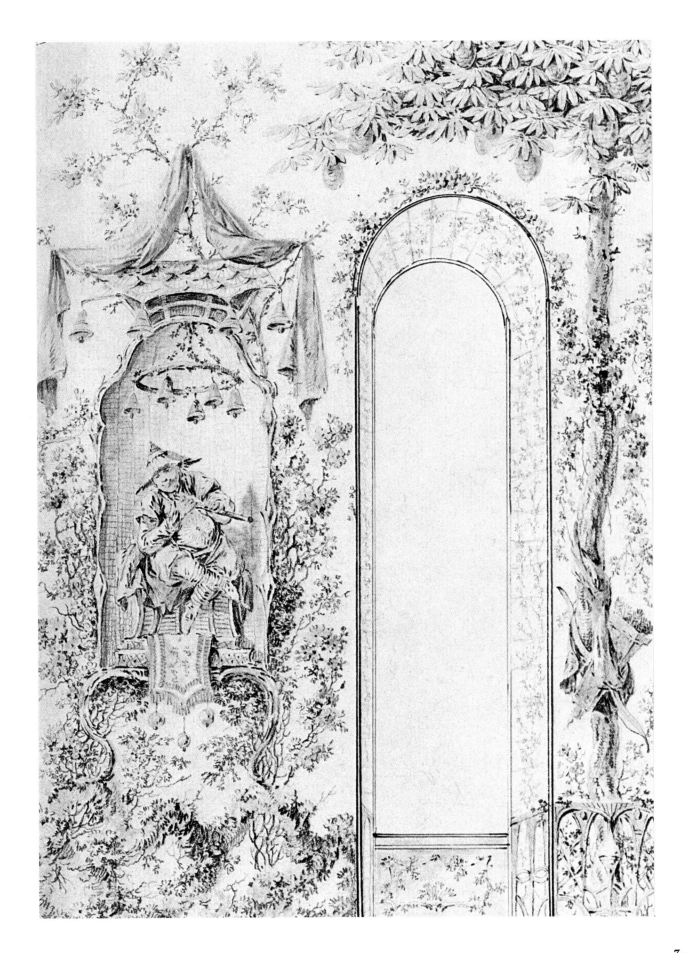

Jean-Honoré Fragonard: *The Runaway Bull.* Watercolor and sepia wash on paper, $12\,^{5}/_{6} \times 16\,^{1}/_{2}$ in. Private collection.

It was during his stay in Italy between 1756 and 1761 that Jean-Honoré Fragonard discovered the qualities of watercolor. But his ability to enthuse over and be astonished at the wonders of nature was a constant characteristic of his genius. There is often a surprise effect in his paintings and drawings. *Le Baiser Dérobé, L'Armoire,* and *La Résistance Inutile* bring the spectators into the presence of an unexpected and at times dramatic incident, which sometimes escapes one or both of the protagonists of the painting. The spontaneous, brilliant technique contributes to the dramatic quality of the scene. We find in this painter of another century such indiscretions as are revealed today by the telephoto lens. This scene was sketched rapidly *sur le motif* somewhere in the Roman Campagna. A peaceful landscape is rudely awakened by the appearance of a bull charging through hilly country, followed by a young lad who has allowed it to escape. The few touches of color, the faint, delicate pencil line, convey the animation of the scene: the clear, translucent air, the charming landscape, the banality, and yet the incomparable beauty of such an ordinary event.

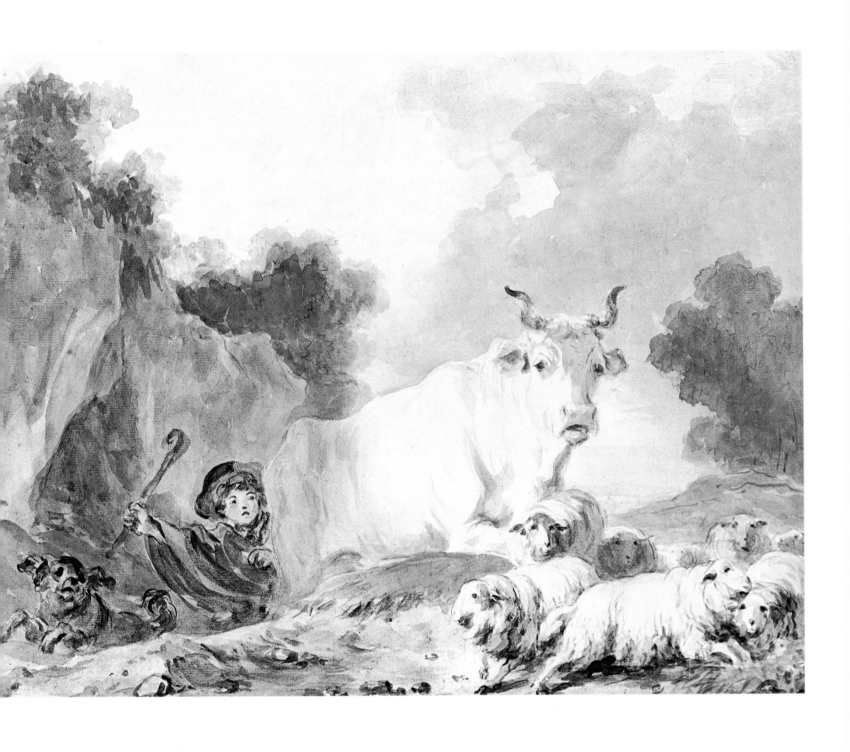

Jean-Baptiste Leprince : *The Russian Cradle*. Watercolor on oval paper, $8^{1}/_{4} \times 15$ in. (detail). Signed : *J. B. Leprince*. Collection of Mrs. A. Hitt, New York.

The public in eighteenth-century France was avid for anything exotic or new. Jean-Baptiste Leprince, a much-neglected painter, became famous by making Russia fashionable, following a sojourn at the court of Catherine the Great. Instead of depicting the Empress and the court, Leprince usually painted pictures of peasants. He had traveled widely across that immense country and, intrigued by the picturesque costumes and strange customs, did a large number of drawings and watercolors on the spot. After his return to France he painted many pictures from these sketches. Leprince's work, however, is principally valuable as spontaneous evidence of the customs and the beauty of a land which no French painter had previously recorded. His watercolors are like a surveyor's drawing. Painting in this medium allowed him to achieve the accuracy in detail, which, added to his gift for perceiving agreeable and touching scenes, permitted him to present a real and always enticing world. Russia is inhabited by people of a physical type not very different from the other peoples of Europe, yet that huge country, with its strange customs and dress, appealed to the current French taste for exoticism without upsetting the firm belief in the superiority of Western practices.

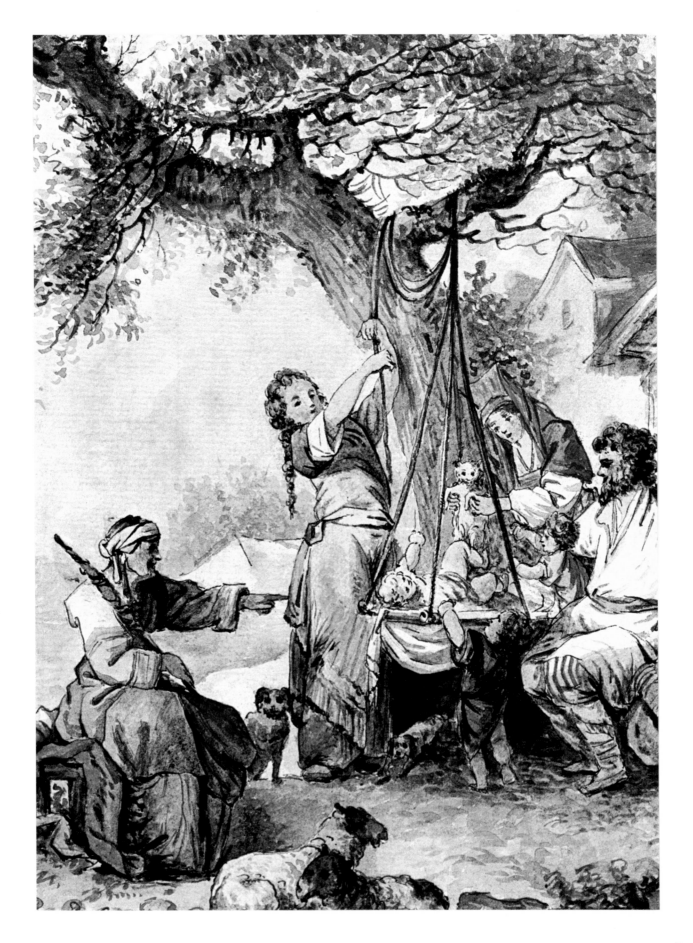

Pierre-Antoine Baudouin : *The Reading*. Gouache on paper, 11 $^3/_8 \times 8 \, ^5/_8$ in. Musée des arts décoratifs, Paris.

Baudouin's great innovation was the use of watercolor to represent in bold detail familiar scenes of the life of high society in his day. Boucher, who was his father-in-law, had also made some excursions into realism, but usually took refuge in mythology for his more daring subjects. Using a brilliant, precise technique, Baudouin reproduced in intimate detail the scenes which an inquisitive watcher might see through a keyhole. The subject of his gouaches is a series of pleasant and cheerful indiscretions. Baudouin did not, however, stress the licentious details, which seem to disappear in the perfect delineation. A girl falls asleep, or pretends to do so, and her bodice falls open. Is she trying to seduce a lover, or is this the image of a *femme savante* tired of books and music ? This picture, carefully prepared and finely executed, seems like one of those stories told by writers of the period, suggesting all kinds of interpretations and moral lessons. The type of realistic gouache made fashionable by Baudouin about 1760 was to be greatly imitated till the end of the century, especially by Lavreince and Mallet. None of them, however, could command the charming false innocence and marvelous skill of Boucher's son-in-law.

44

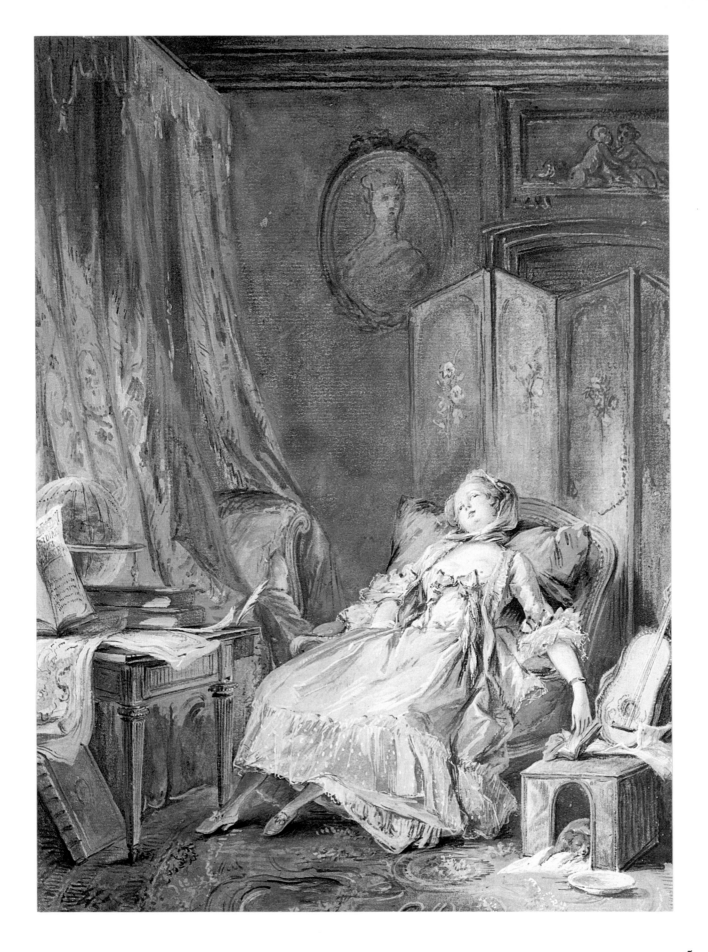

Louis Durameau: *The Saltpeter Works* (1766). Gouache on paper, $20\,^7/_8 \times 15\,^3/_4$ in. Exhibited in the Salon of 1767. Musée du Louvre, Paris.

This gouache is one of the most singular works of the eighteenth century. Its creator was a very brilliant artist with a varied talent, whom unfortunate circumstances kept in obscurity. At the beginning of the reign of Louis XVI he was considered to be one of the best French painters. An ambitious man, he accepted the most difficult commissions and produced, among other things, several very large decorative scenes. Most of them have been destroyed. Many of his easel paintings must certainly still exist in collections and museums, but wrongly attributed to more famous painters. This gouache, done in Italy, is one of the rare descriptions of workmen at their labor in French classical painting. Industry had always been considered a subject unworthy of art, incompatible with beauty. The same prejudice was to be found in literature. With audacity and originality, Louis Durameau, a man of unlimited inspiration, depicted the atmosphere of a saltpeter factory, showing the men working with great effort. Of all the writers of the period only Diderot, the encyclopedist, was as interested as Durameau in reporting working conditions. Done in the course of a journey to Italy, this gouache clearly shows the influence on the young French painter of southern artists, who had been using watercolors regularly since the first half of the eighteenth century.

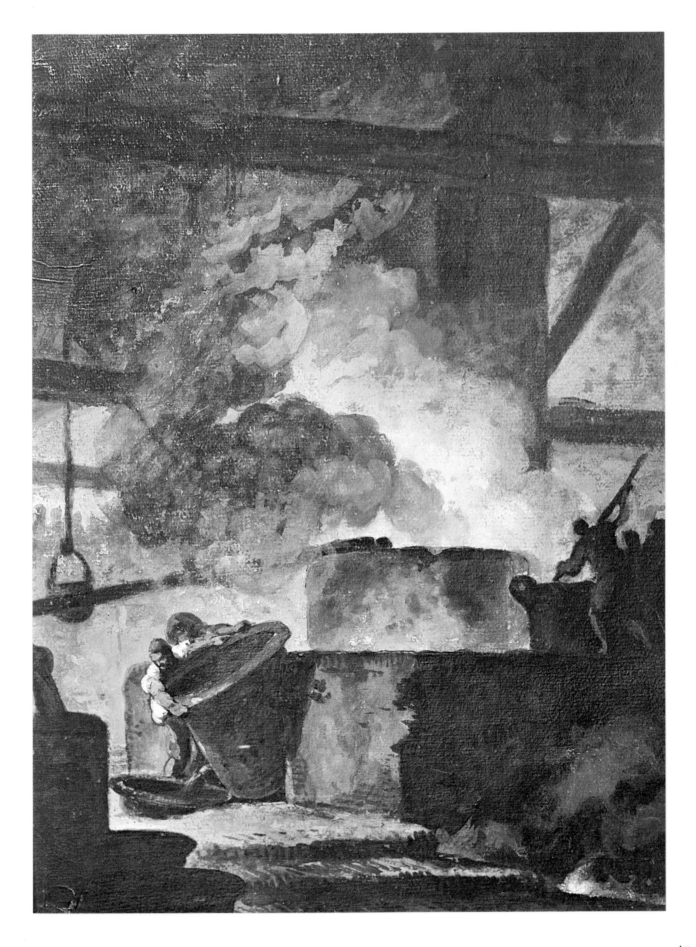

Jean-Honoré Fragonard: *The Bed*. Pen and Chinese ink and watercolor on paper, $18\,^1/_8 \times 11\,^3/_4$ in. Musée de Besançon.

Even when working in oil, Fragonard painted like a watercolorist. He saw nature not as objects separated one from another, but principally as colors and light; he was especially interested in representing atmosphere, in painting shadows and luminosity. This watercolor is a good example of Fragonard's original genius in subject and technique. Nothing could be more evocative than the unmade bed, the crumpled sheets and disturbed covers, which suggest the lovers' presence more strongly than if they were there. Love is by no means an artificial symbol in this realistic evocation of sensual pleasure. The technical means chosen to give the picture life are spirited, discreet, and seductive. Nothing is indicated with too much precision. The line is often hazy so that one must guess at certain details of the bed. Undoubtedly there is something quite arbitrary in the yellows and reds of this white sheet. Extreme economy of means, reality, and sentiment contribute in creating an incomparable intensity of feeling. The watercolor of the eighteenth century comes into its own here: this delicate, pale sketch on white paper excites and transports us because it is a breath of life.

49

Hubert Robert: *The Public Fountain* (1770). Pen and watercolor, $12\,{}^5/_8 \times 19\,{}^5/_8$ in. (detail). Signed: *Fontem hanc publicam viatorum commoditati struxit H. Robertus anno domini 1770*. Private collection.

In Italy young French artists discovered the sun, brilliant color, and the beauty of ruins. Watercolor as it was handled by many Italian artists was almost unknown in France at the time, and it seemed to be a technique specially developed for representing the transparency of light and the fragility of time. But Hubert Robert would not have been an eighteenth-century Frenchman if he had not tried to express these new and stirring interests with cheerful irony. Very much the realist, he eagerly drew all kinds of ruins and landscapes with touching exactitude. He was fascinated by classical antiquity, and included imaginary ruins in all his gardens, starting a fashion in France. However, he could not resist adding a children's game, a lovers' meeting, and working washerwomen to these most majestic classical remains. Robert loved the contrasts between daily life and museum pieces, and between scrupulously observed nature and unbridled imagination. Fountain, figures, light, and landscape: everything is Italian in this watercolor, yet nothing is entirely real. Hubert Robert let his imagination run on to the point of painting a Latin inscription instead of a signature: "Hubert Robert made this fountain in 1770 for the comfort of travelers." And it is true that after two hundred years this watercolor, fresh as limpid water, reveals the sweetness of life to the viewer.

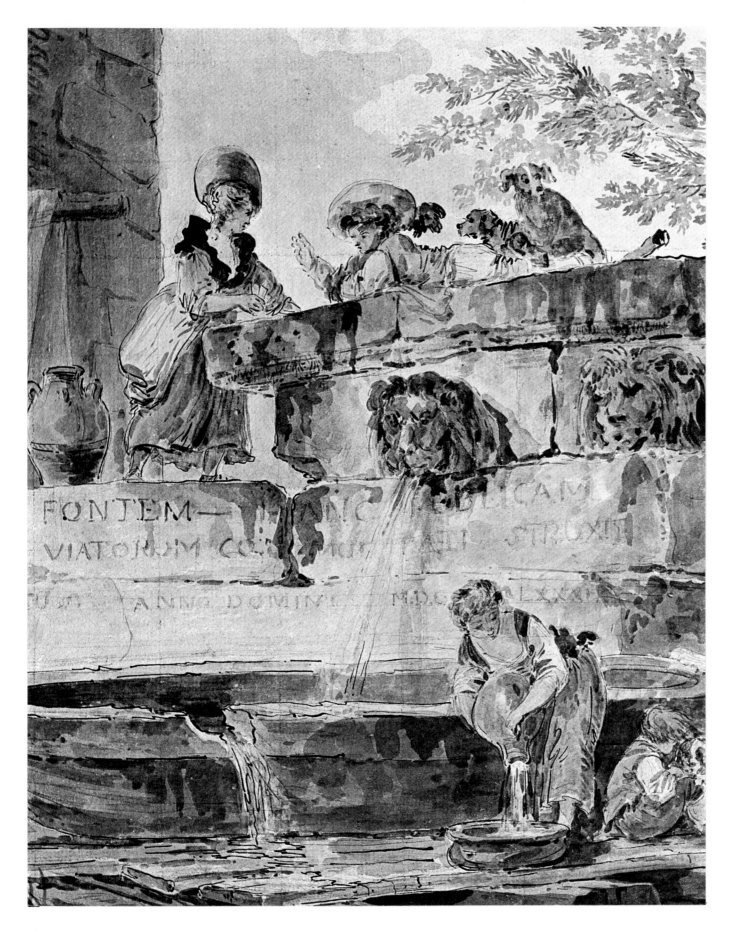

Within the illustration, the following inscribed text appears:

FONTEM · · · · ANC · · · · BLICAM
VIATORUM CO· · · · · · · · · · STRUXIT
· · · · ANNO DOMINI · · · MDC· · · · · LXXX· ·

Gabriel de Saint-Aubin: *The Comte de Provence Reviewing His Regiment* (1771). Ink wash and watercolor on paper, 5⁷/₈ × 4⁵/₁₆ in. Signed on the left at the bottom: *Fait par Gabriel de St. Aubin*. Signed on the reverse: *G. de S A 1771, 15 décembre auteur de l'Allégorie du mariage de Mgr. le Comte de Provence*, Archives nationales, Paris.

The Comte de Provence, grandson of Louis XV and future king Louis XVIII, is reviewing his regiment. The light was so beautiful that Gabriel de Saint-Aubin was tempted to sacrifice color. The Parisians who used to come to the plain of Sablons, at the gates of the capital, where most of the reviews took place, used to complain that in dry weather clouds of dust covered some of the spectacle. The white paper suggests the dust, while Saint-Aubin laid stress, not without a certain malice, on the clumsy gesture and incipient *embonpoint* of the twenty-year-old prince. This watercolor is the frontispiece in the inventory of the regiment of the Comte de Provence. The taste for decorating the plainest archives with pleasing paintings contributed a great deal to the fashion for watercolor in the second half of the eighteenth century.

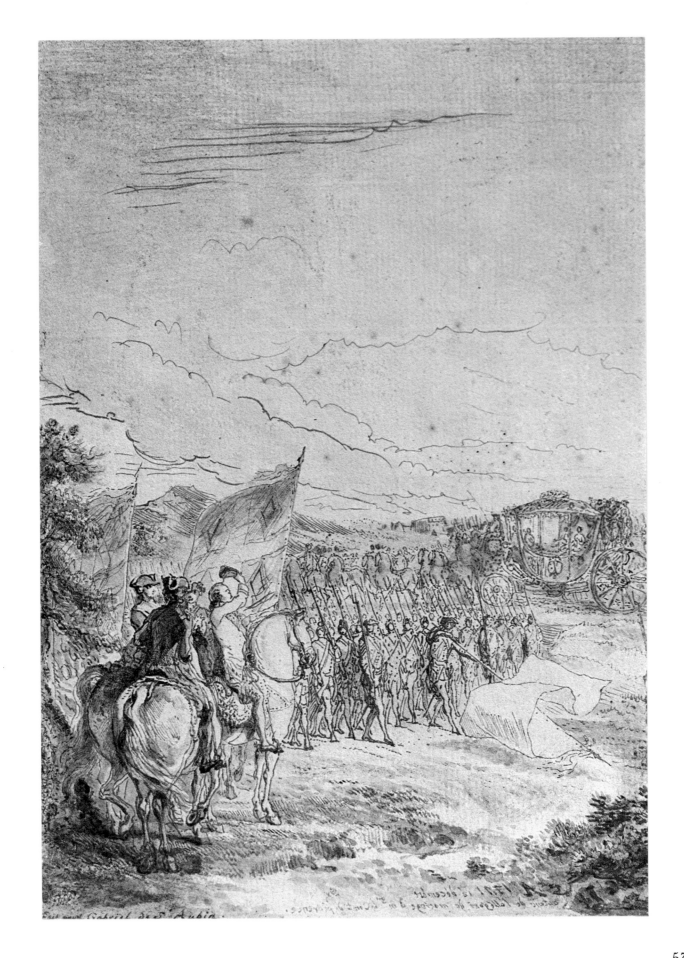

Fait par Gabriel de S.^t Aubin

Jean-Honoré Fragonard : *The Toilette of Venus*. Pen, wash, and watercolor on paper, 16 $^{15}/_{16}$ × 9 $^{13}/_{16}$ in. (detail). On the binding is written : *Fragonard 1780*. Musée du Louvre, Paris.

Marvelously talented as a designer and colorist, Fragonard always seemed torn between opposing subjects : religious or licentious, realistic or artificial. The reason for his liberal inspiration was his ebullient temperament, which allowed him to approach any theme with the same easy familiarity, and to paint the Virgin, the goddesses of Olympus, heroines of mythology, or celebrated dancers in the guise of the young peasants encountered near the fountain. Venus at her mirror was a classic theme for Boucher and his pupils in mid-century. But while for them it was a question of deifying with the traits of Venus a noble or bourgeois lady desirous of transcending her human frame, the goddess of beauty for Fragonard is simply a pretty girl looking at herself in the glass. Boucher preferred to paint in oil or sometimes in gouache, and these slower processes harmonize with his tendency to idealize. Fragonard was a natural watercolorist, painting rapidly a pretty scene either from life or from his own imagination. Color in this case is part of the drawing and its pale tones enliven and draw out the wash.

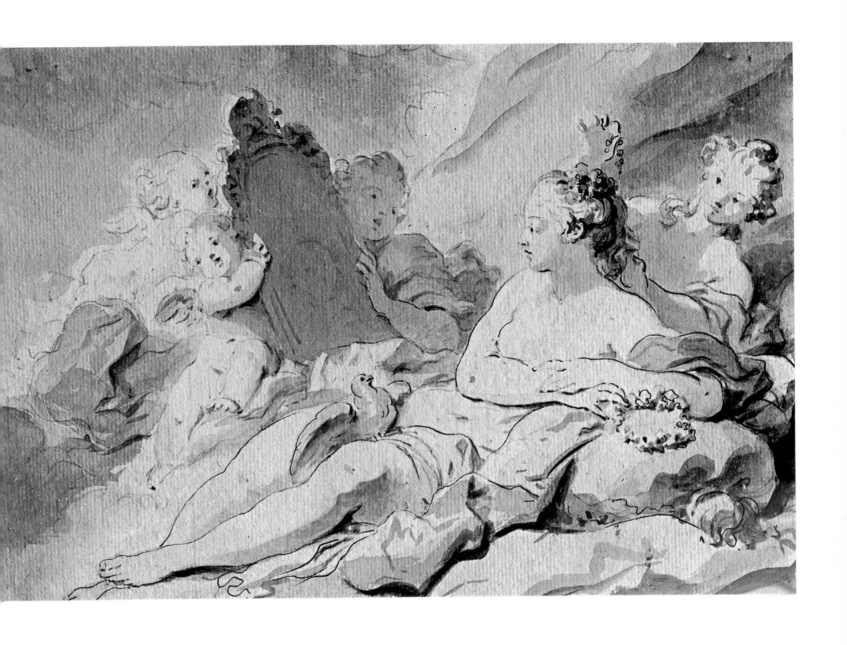

Louis de Carmontelle : *Mmes. la Marquise de Montesson, du Crest, and de Damas Taking Tea* (1773). Pencil and watercolor on paper, $13^{3}/_{8} \times 9^{1}/_{16}$ in. Musée Carnavalet, Paris.

A painter of charming watercolors, Louis de Carmontelle believed that he was making records in a personal journal rather than executing works of art. He had been commissioned to make military reliefs before he was attached to the Dukes of Orléans. He wrote short plays for amateur dramatics, organized *fêtes*, and used his talent for portraiture to record the visitors to the Palais-Royal and the château of Saint-Cloud. Carmontelle's technique was rudimentary. His characters were drawn and framed in pencil, then simply filled in with simple bright colors. His contemporaries agreed that you could recognize one of Carmontelle's portraits if you met the model in the street. Carmontelle's scenes are still striking today. Without either cruelty or indulgence he reveals the ugliness of a face, awkwardness of attire, or clumsiness of gesture. This incomparable naïveté allows us to discover, with an indulgent smile, the habits, attitudes, ways of living, and a certain aspect of a period which neither literary descriptions, documents, nor easel paintings could express, and which in general have vanished altogether. Carmontelle discovered an original aspect of watercolor that is unequaled in the works of even the best mid-twentieth-century photographers; by their very inadequacy and in spite of their charm, they demonstrate the superiority of watercolor for capturing a moment of life.

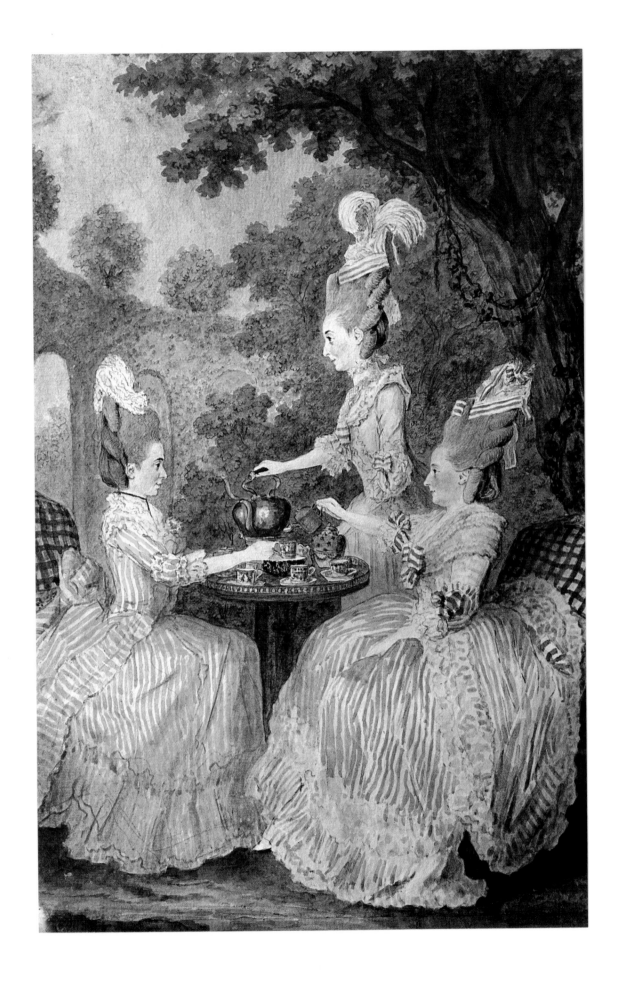

The Chevalier de Lespinasse : *The Place Louis XV Seen from the Champs-Elysées* (1775). Pen, watercolor, and gouache on paper, $7\,^7/_8 \times 13\,^3/_8$ in. (detail). Musée Carnavalet, Paris.

Parisians love their city and views of Paris have always interested collectors. The Chevalier de Lespinasse, a designer and landscape painter, instilled new life into a popular style by carefully mixing drawing and watercolor. He skillfully blended the perspective frequently used for plans of cities with straightforward representations of the urban scene. Lespinasse's large watercolors are done from an imaginary high viewpoint. All the details are vigorously exact. The huge building in the distance is the palace of the Tuileries, destroyed about a hundred years ago, which stood at the end of the garden. Opposite the statue of Louis XV, a revolving bridge over the moat gave access to the garden. The niches in the two palaces on the left—today the Hôtel Crillon and the Ministry of the Marine—were still waiting for their statues, which had not yet been made for them at the time of Louis XV. The moats encircling the square were filled in during the nineteenth century, and to the far right a bridge, built at the end of the reign of Louis XVI, stretched over the Seine, extending the causeway. The central alley was the beginning of the present Champs-Elysées, which was only a promenade in the time of Lespinasse. Although the fountain on the right is still there, the statue of Louis XV by Bouchardon in its wrought-iron grille in the middle of the square was torn down during the Revolution and replaced fifty years later by an obelisk. Watercolor was the only technique which could have enabled Lespinasse to paint such a minutely detailed panorama with such vigor.

58

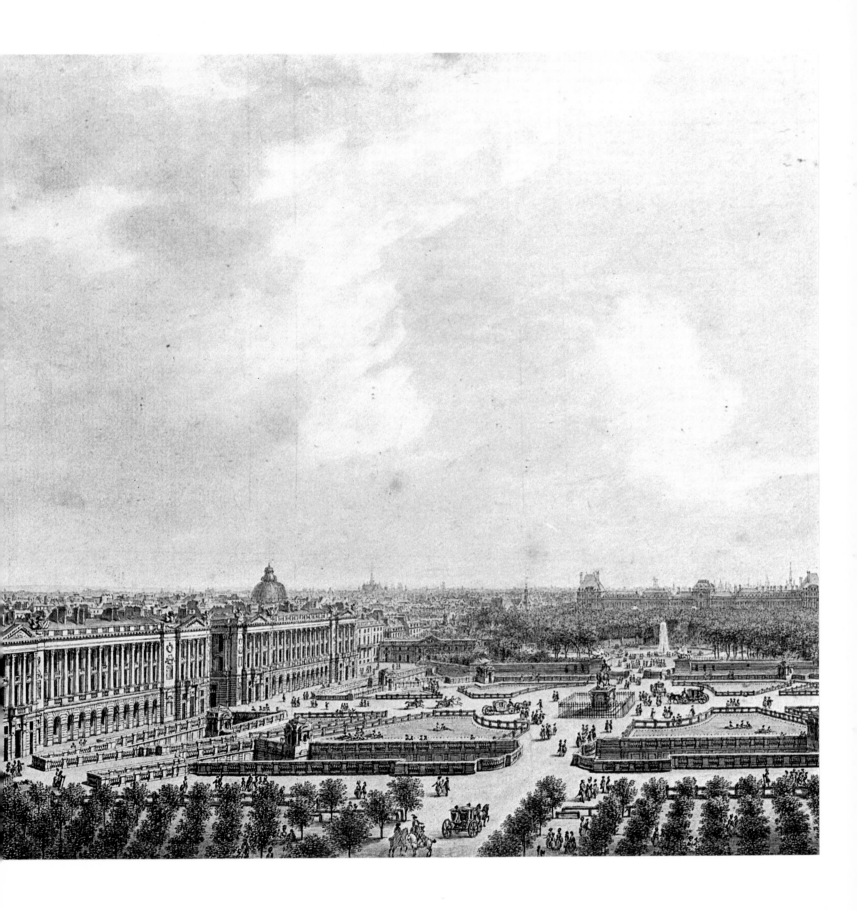

Gabriel de Saint-Aubin: *A Sale of Paintings* (1776). On the reverse is written: *Vente de tableaux 1776.* Watercolor and gouache on paper, 5 ⁷/₈×3 ¹⁵/₁₆ in. Musée du Louvre, Paris.

Painting in the eighteenth century, like philosophy, ignored the mystery, dark secrets, and shining illuminations of chiaroscuro. Boucher neglected questions of lighting in the same way that Voltaire chose to forget everything that passed a man's understanding. Gabriel de Saint-Aubin, who was very close to his contemporaries in his passion for exact description, his attempt to catch the passing moment, recalls Rembrandt, Caravaggio, or Georges de La Tour in his love of unexpected light effects. Nothing could be more equivocal or mysterious than an auction sale where beauty, so incapable of measurement, is judged by its weight in gold, with collectors competing for works by the greatest painters, sometimes for love of the paintings, sometimes out of a competitive spirit, or sometimes for simple love of gain. What more suitable subject for a painting than an auction sale of pictures? Daumier is one of the few artists who could compete with Saint-Aubin in interpreting this strange spectacle. At home with pencil, gouache, or watercolor, Saint-Aubin found with unerring skill the best technique to express most adequately the singular tension of this extraordinary battle by candlelight. The back lighting and shadow play give a comic character to the contortions of the bidders.

Marie de Saint-Aubin: *Young Lady Painting a Portrait of Cupid* (1776). Watercolor on paper, $9\,^7/_6 \times 5\,^7/_8$ in. Private collection.

In this watercolor by an amateur artist, preserved in a treasured collection which also contains several of the finest works of Augustin and Gabriel de Saint-Aubin, the graces are naïvely united. The successes of great painters and the clumsy efforts of other members of their families constituted precious souvenirs for all the Saint-Aubin family. They are immortal records, as are all the watercolors of eighteenth-century France. It is certainly a portrait of Cupid the girl with the tender and dreamy eyes is painting. However, a priest is visible near the window, partly hidden by a chair and a dressing table. At the foot of the easel, a child has put his raquet and shuttlecock on the ground while he plays with a dog. Despite the appealing awkwardness, the painter's tools, pallette, brushes, and wrist-rest are drawn with great precision. The light touches, the soft and indefinite strokes, correspond well with the expression and attitude of the young girl in the center of the composition, so delicately outlined in her light-colored gown. It all emphasizes the femininity of watercolor, which allows one to be diffident, and to sketch sparsely, leaving to the spectator the pleasures of his imagination.

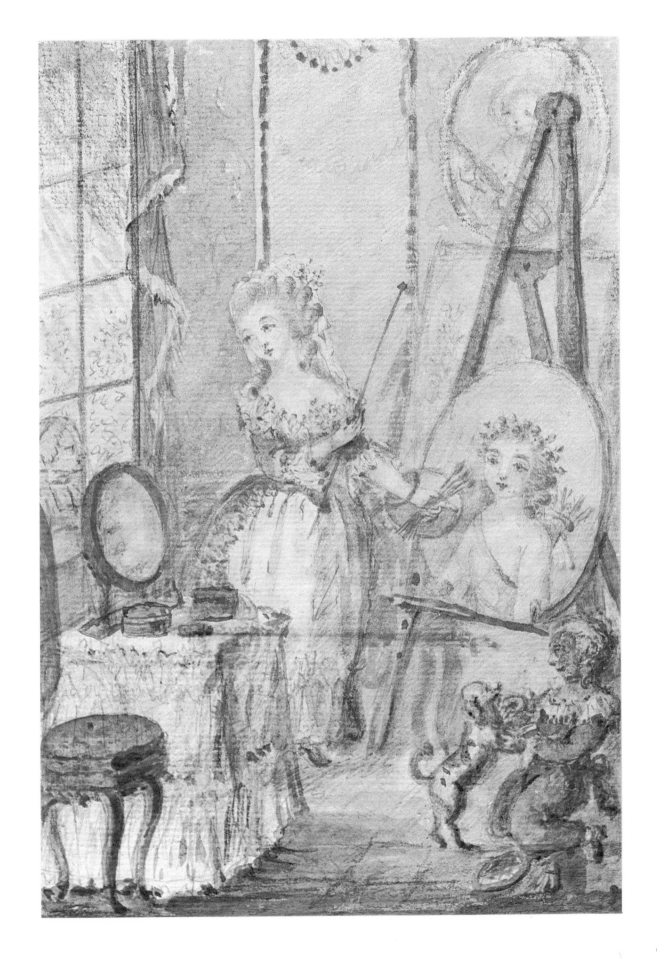

Claude Hoin: *Mlle. Dugazon in the Part of Nina, or, The Woman Mad with Love, a Play by Marsollier* (1776). Watercolor on paper, $7^7/_8 \times 6^1/_4$ in. Signed: *Hoin pinxit*. Private collection.

The woman seated here on a bench in a flowery park is in reality an actress on a theatrical set. Mademoiselle Dugazon had enjoyed a great success in the principal role of a play by Marsollier produced early in the reign of Louis XVI. The character of Nina, mad with love, became very popular, and Claude Hoin, a poetic artist, was inspired to paint her. His work was so successful that it was imitated many times. Hoin, whose drawings have the flowing outline of a painting without contrasts and who knew how to give a misty transparency to his line, used watercolor alone here, taking full advantage of the light background of the paper to brighten the composition. The theater, for Hoin, as for many of his contemporaries, was so intimately linked with reality that this imaginary scene became a real garden. Nothing is out of place in its pleasant evocation of love and beauty. The subtle shading permits the passage from blue to red through the yellow, with each color suffusing in the white paper, and adding to the softness of the pale harmony.

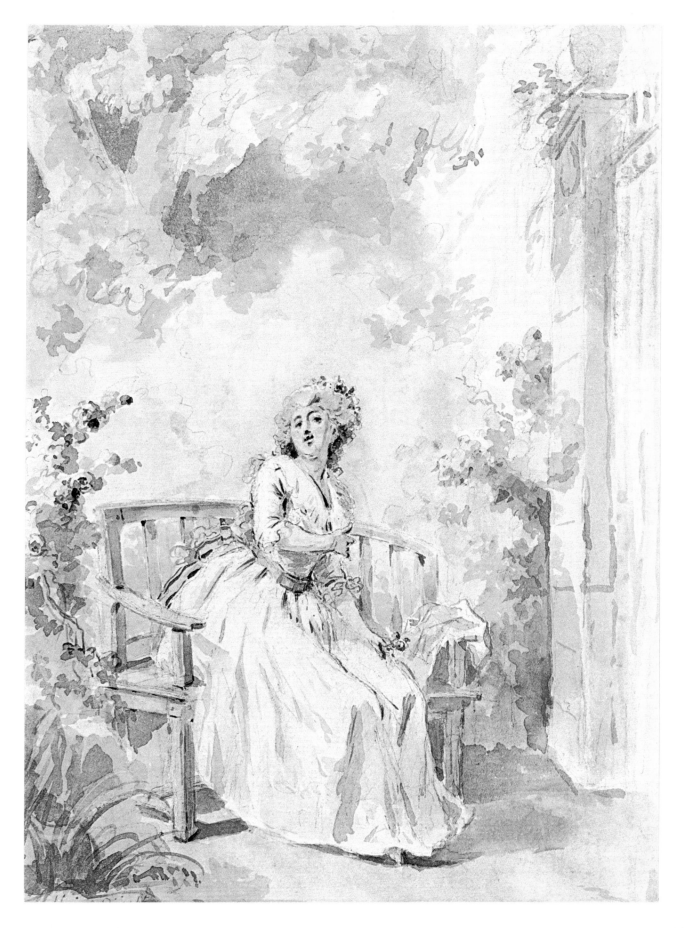

Gabriel de Saint-Aubin : *The Shop of Mlle. Saint-Quentin* (1777). Pen, watercolor, and gouache on paper, $7\,^7/_8 \times 3\,^{15}/_{16}$ in. Signed : *G. de St-Aubin 15 janvier 1777, boutique de Mlle St-Quentin, Rue St-Honoré au Magnifique, De G.* Private collection.

Gabriel de Saint-Aubin was an inspired stroller. In the special field of representation of the most ordinary and banal scenes he proved himself to be really superior to the most famous painters, because he had no prejudices. He did not accentuate the tragic or comic aspect of a situation, but continually varied his technique. He had a gift for admiring such a banal scene as the visit of clients to a fashionable shop and for transforming it into a captivating scene. Saint-Aubin did not try, like Watteau, to arrange his figures cleverly, or to stylize attitudes and physiognomy in the manner of Degas or Lautrec. The watercolor he used in so many different ways—as ink, gouache, and pure color—allowed him to present people, not in isolation, but in a scene in its entirety, as a confusion of light, form, and color. The Rue Saint-Honoré, where the shop evoked by Saint-Aubin was situated, was, in the eighteenth century, as it still is today, one of the busiest in Paris. Lit only by the light from the narrow street, the shop is bathed in an atmosphere as dark as the games and secrets of coquetry and fashion.

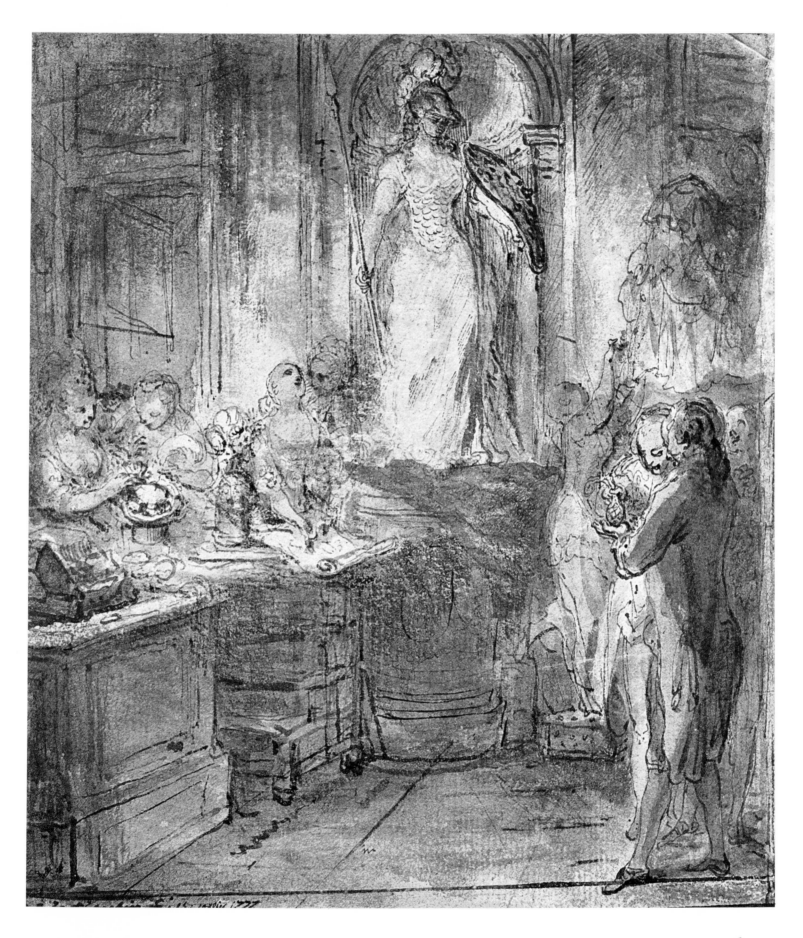

Jean-Michel Moreau: *Thoas' Costume Designed for Gluck's Opera Iphigénie en Tauride* (1779). Pen and watercolor on paper, $8^5/_8 \times 5^7/_8$ in. Private collection.

Jean-Michel Moreau painted and drew as others write. He was a very rapid and prolific worker, and all his work done before the French Revolution displayed the same grace and wit as Voltaire's correspondence. His line and color were always spirited. Moreau was commissioned to record a chronicle of life at court. He carefully represented the *fêtes* when they took place, and also had a hand in organizing them. Few artists could so well evoke the giddy round of eighteenth-century high-society life as Moreau, for whom the picture of a completed spectacle and the plans for the next entertainment—the future and the past—became inextricably intermingled. Commissioned to design costumes for the presentation at the Paris Opéra of Gluck's *Iphigénie en Tauride,* he was not satisfied to show just the color of the materials, the cut of the gowns and garments. Moreau had to depict each character in his role so as to dress him suitably. For this artist, watercolor was not just a convenient means of showing a precise color; it was above all the very manifestation of a project, a dream, a hope.

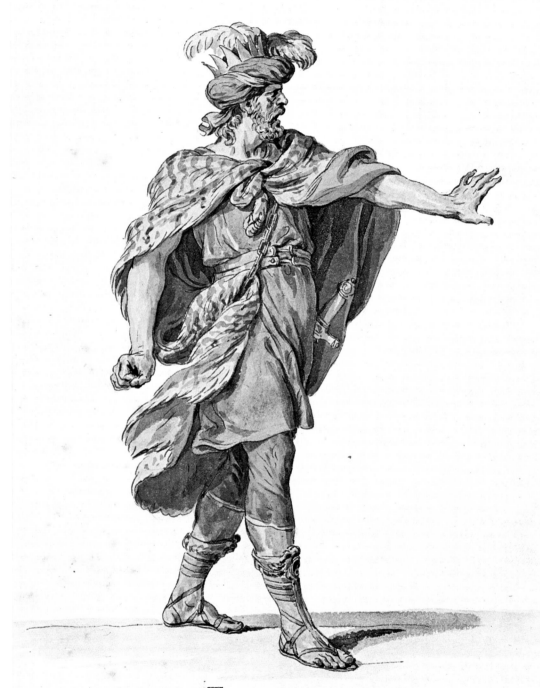

THOAS

Tunique de Satin ponceau. manteau doublé de Satin verd. Plumes
d'un gris Roussâtre; & d'autres noires.

Nicolas Lavreince : *The Departure.* Gouache on paper, $9^7/_{16} \times 7^1/_{16}$ in. Private collection.

Nothing was more characteristic of the feeling of well-being prevailing among French high society at the end of the eighteenth century, even before this euphoria spawned the optimism of the Revolution, than the fashion for recording simple everyday events. Beauty did not lie in the splendor of the past, or even in the hope for a better future. One had only to look at oneself and the world around one to discover it. This naïve and presumptuous satisfaction is perhaps best expressed in the work of an artist who was not French and not endowed with a particularly brilliant or prolific imagination. Nicolas Lavreince was a Swede settled in Paris. He simply ignored the mysteries of life and painted very skillful and agreeable decorations. It was enough for him to record the fleeting image of a gesture, of an interior, of an entertainment. Inspired very much by Baudouin, whose technique he copied and whose success he inherited, he had no need, as tastes had changed, to choose sensual and stimulating subjects to demonstrate this pleasant reality. He worked seriously, and brilliantly and successfully revealed the charm of a world in which people were content to regard only themselves. A trick of reflection, often found in paintings at that time, a glove slipped into a delicate hand, tell the whole story in a painting which silently expresses the charm of simple happiness in existence.

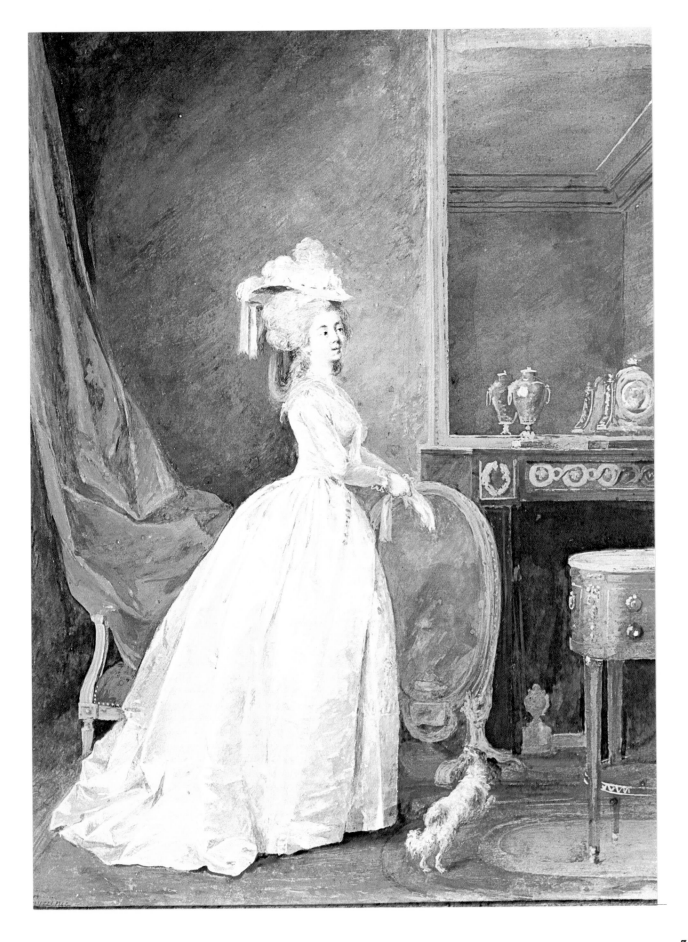

Louis Moreau: *Walk in the King's Garden*. Watercolor and gouache on paper, $11 \times 7^{1}/_{2}$ in. Private collection.

Louis Moreau was a Parisian who did not care for the urban scene. He always seemed to be trying to escape to the trees and flowers, the green countryside and broad perspectives. If he could not get out into the country he would walk in the King's Garden, now the Jardin des Plantes, long presided over by the writer and naturalist Buffon. This delicate work is a good example of Moreau's technique. He used the white of the paper as much as possible to represent light and air. There is rarely a pencil line, though gouache sometimes heightens the delicate touches of his watercolor. Moreau expressed landscape in a manner later adopted by Corot and Monet. He did not worry about the details of his subject or try to represent exactly what he saw. It was the charm of a walk, the trees, and the blue sky that he recorded for us to admire, preserving his impressions in watercolor. In his most inspired work, it is as difficult at first sight to discern the meaning of a detail as in the *Nympheas* of Claude Monet or the southern landscapes of Bonnard. Of course, these mysteries in no way resemble the intentional schematization of the Cubist or Abstract painters; they arise from a feeling for color so accurate that the import of an inexplicit line or color becomes open to interpretation.

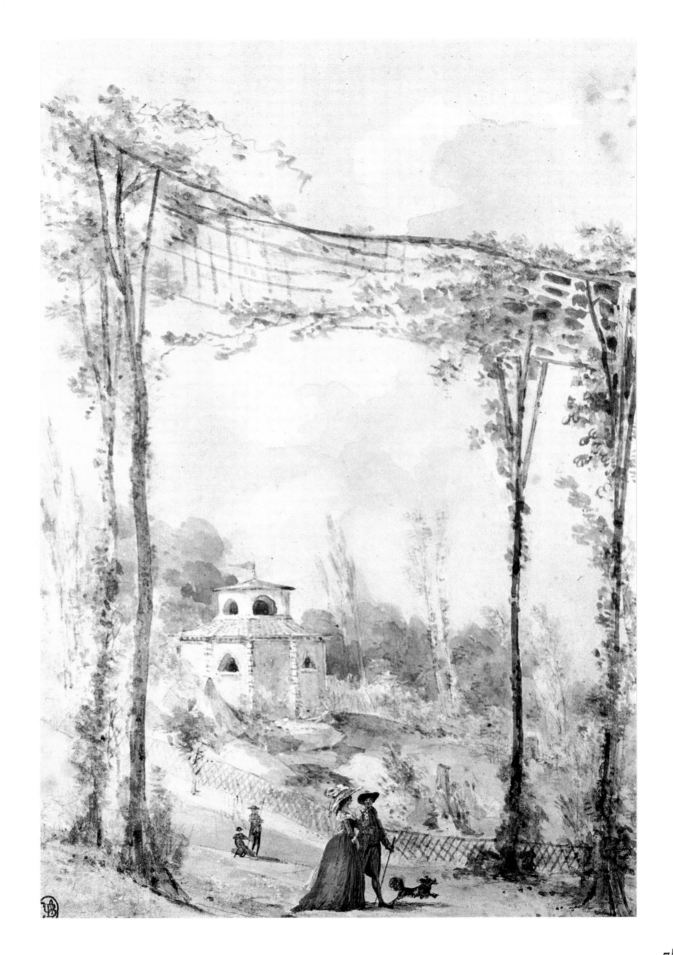

François Dumont: *Marie Antoinette* (about 1780). Oval ivory, $5\,^{1}/_{8} \times 3\,^{15}/_{16}$ in. (detail). Collection of Mme. N. Perron.

The revival of the miniature in the second half of the century is one aspect of the rehabilitation of watercolor painting. François Dumont, a great favorite with Marie Antoinette, was given several opportunities to paint the Queen in her own background. The miniature has a more intimate and spontaneous character than the kind of oil painting reserved for official portraits. Marie Antoinette loved her dogs and flowers, enjoyed playing the harp, and much preferred to pass the time alone or with friends in her private rooms rather than in the great salons open to the public. This portrait was the one she chose to give to those close to her. Miniatures, because of their small size, were often used to decorate a box, a table, a jewel, or a trinket. Such paintings escape the often cold solemnity of formal works of art and approach the pleasing simplicity of decorative art.

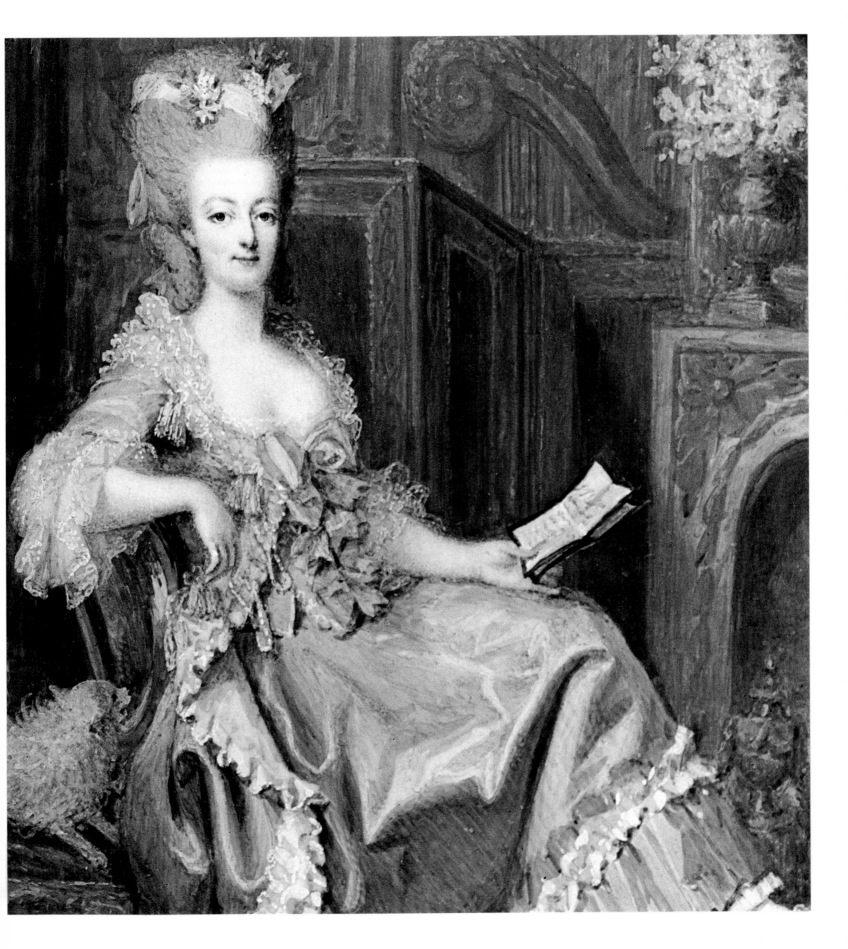

Claude-Louis Châtelet : *Saint-Preux and Julie*. Watercolor on paper, $13^{3}/_{8} \times 10^{5}/_{8}$ in. Signed : Châtelet. Private collection.

Claude-Louis Châtelet was deeply involved in the dramatic events in France at the end of the eighteenth century and played an important role in the history of art. The fact that Marie Antoinette gave him the task of recording her Trianon garden did not keep him from being a member of the Revolutionary tribunal, or from sending a number of suspects to the guillotine before being beheaded himself after the fall of Robespierre. This passionate man loved the tragic side of the arts. He created in oils and in watercolor the melancholy of the Romantic landscape. Eighteenth-century painters saw nature as smiling and occasionally moving; Châtelet saw it as often pathetic, as it was to appear in the following century to Delacroix, Géricault, and Girodet. To describe mountains, rocks, and fearful precipices Châtelet employed a bold technique using line, watercolor, and gouache. The technique was ahead of its time, and displays his interest in experiment. In this watercolor, as in his larger oils, he invented Romanticism in painting. The subject of the work clearly shows its parentage : Jean-Jacques Rousseau and *La Nouvelle Héloïse*, which inspired him to discover a plastic equivalent for these sentimental themes.

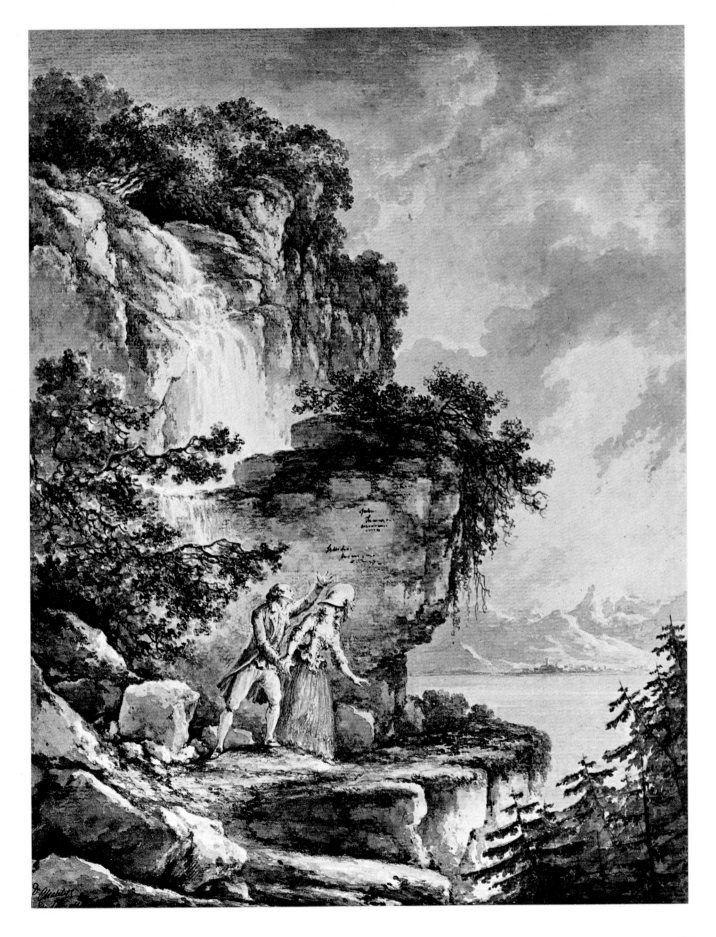

Jean-Louis Desprez: *Transporting the Antiquities of Herculaneum from the Museum of Herculaneum to the Museum of Naples* (1781). Watercolor on paper, $8^{1}/_{4} \times 14^{1}/_{4}$ in. (detail). Illustration for Saint-Non's *Le Voyage Pittoresque*. Private collection.

In the eighteenth century, the rediscovery of antiquity, far from strengthening tradition or favoring a return to the past, provoked political change and brought about a new philosophy of life. Jean-Louis Desprez, an artist of varied talent, a painter, architect, and decorator with a temperament now realistic, now visionary, saw the removal of the treasures of Herculaneum to Naples much more as a great entertainment than as the creation of a museum. The past was reborn in the present, the slow procession of the centuries was abolished, the derisory brevity of man's time on earth was underlined. Desprez experienced keenly the romantic feeling of the time, and his lyricism heralded the nineteenth century. However, he could not resist an agreeable irony when faced with ruins and death. The exaggerated line of his drawing in black ink outlines the somber tones of his watercolors. Desprez was inspired by a real event to create an elaborately careful work in which design is more important than anecdote. This scene was done with the intention of its being reproduced as an engraving for an immense work: *Le Voyage Pittoresque à Naples et dans les Deux Siciles*, conceived and published by the Abbé de Saint-Non. Many French artists were given an opportunity to try their hand at watercolor by commissions for this magnificent book.

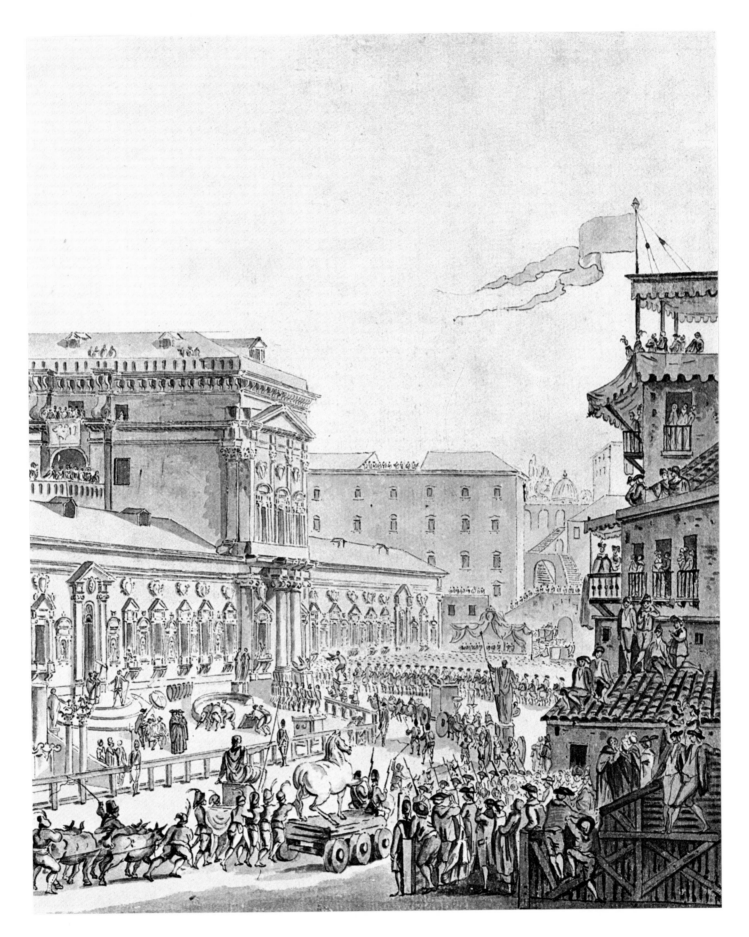

Jean-Honoré Fragonard : *The Marmot ; Rosalie Fragonard in Savoy Costume.* Bister wash and gouache, $10^{1}/_{4} \times 8^{1}/_{4}$ in. Albertina Museum, Vienna.

Watercolors by Fragonard are rare, but gouaches that can be confidently attributed to him are almost unknown. This portrait of Rosalie Fragonard wearing Savoy costume and displaying a marmot, identical with the famous oil painting by the same artist, is undoubtedly authentic. During Fragonard's life this gouache was in the collection of the Archduke Albert of Saxe-Teschen, brother-in-law of Marie Antoinette and governor of the Austrian Netherlands, now Belgium. In Fragonard's day all kinds of odd trades were to be seen in Paris, and there were many provincial costumes to delight the eye of painters and engravers. The conventional uniform of the street did not become common until the Revolution. Savoyards were quite numerous in France. Their mountain country was very poor, but they easily found employment for the winter in Paris. Selling tame marmots enabled them to earn a few pence. Rosalie, Fragonard's favorite daughter, died very young. This was probably an initial sketch from life. Gouache, a technique nearer to oils than watercolor, must have allowed Fragonard to make a more accurate assessment of color for the final work.

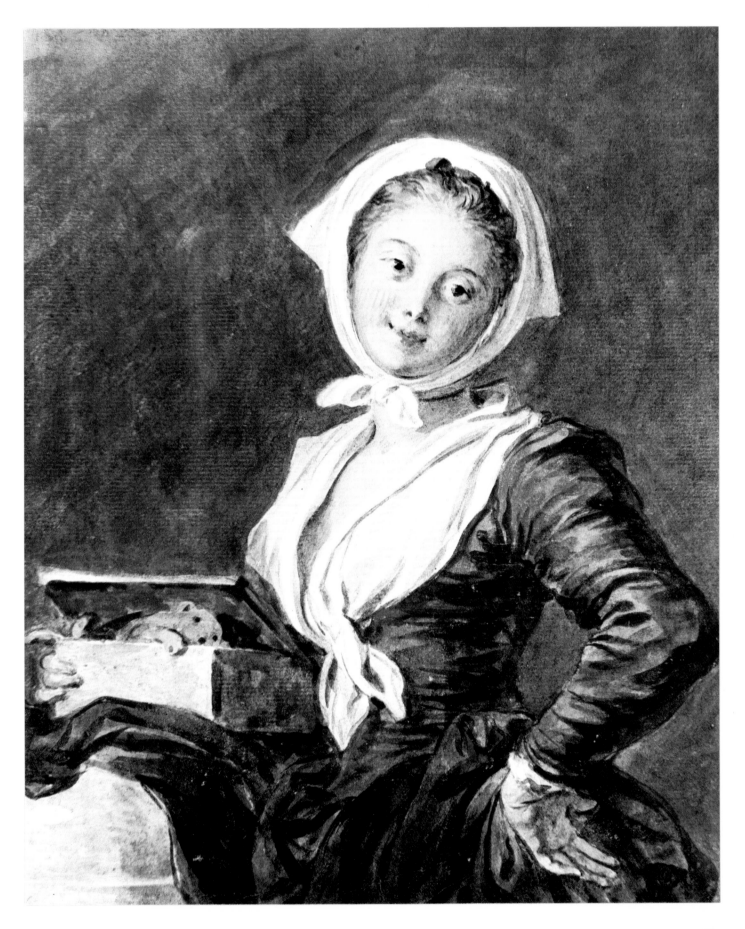

Louis Moreau : *The Terrace of Vincennes*. Gouache on paper, $16^{1}/_{4} \times 15^{3}/_{4}$ in. (detail). Private collection.

The reason Louis Moreau was received so indifferently in his own day was that his approach to nature was almost incomprehensible to his contemporaries and probably much nearer to our own ideas. In the eighteenth century landscape was only a decoration, the background for human figures which were always the chief theme of a painting. Corot and the Impressionists were to realize much later that it is not the elements of a landscape that are important, but the light and the atmosphere. Long before their day, Moreau, an indefatigable walker among the hills and gardens on the outskirts of Paris, had realized that the sky alone could be the subject of a painting and that a human being is often a good deal less picturesque than a tree. Louis Moreau's methods are not exactly known, but most of his pieces must have been done *sur le motif*, for they are extraordinarily accurate and well observed. Generally Moreau does not even seem to have bothered to choose a good subject, such as a well-known place or building. In this case he painted the sky, the flowers, and the surroundings of Vincennes, but the château itself is a minor feature. This is already an Impressionist idea of landscape. Moreau was never accepted as a member of the Academy of Painting. His revolutionary idea of landscape must have shocked his contemporaries. But he was always able to find collectors for his gouaches and watercolors.

84

Jean-Baptiste Le Paon: *Chasing the Stag in the Grand Canal at Chantilly*. The hunt of June 12, 1783, held in honor of the Comte du Nord, the future Tsar Paul I. Pen, sepia wash, and watercolor on paper, $18^1/_8 \times 33^1/_{16}$ in. (1783). Bibliothèque de l'Ecole Polytechnique, Paris.

The chase, and more particularly stag hunting, was one of the most popular activities of society in the time of Louis XVI, probably because it was the only sport, the only physical exercise considered fashionable, perhaps also because it enabled courtiers to escape from despised official rites and ceremonies, and finally because of the gay atmosphere of a day's hunting in the country. The chase was an essential theme of painting at this period, and artists like Oudry and Desportes devoted nearly all their time to it. But if Desportes painted his animal studies only in oils, and if Oudry—at times a watercolorist—principally drew studies of the chase, it was because they both belonged to the first half of the century. This large watercolor was probably done by Le Paon in 1783 to record his immediate impressions before executing an important oil painting of the same subject, which was given by the Prince de Condé to Tsar Paul I and is still in Russia. Water and air are represented with very little contrast in tone, but the mingling of wash and watercolor perfectly expresses the swarming crowd beside the château of Chantilly, the accumulation of incident and detail, the stag, boats, canals, and the brilliant light of a fine day.

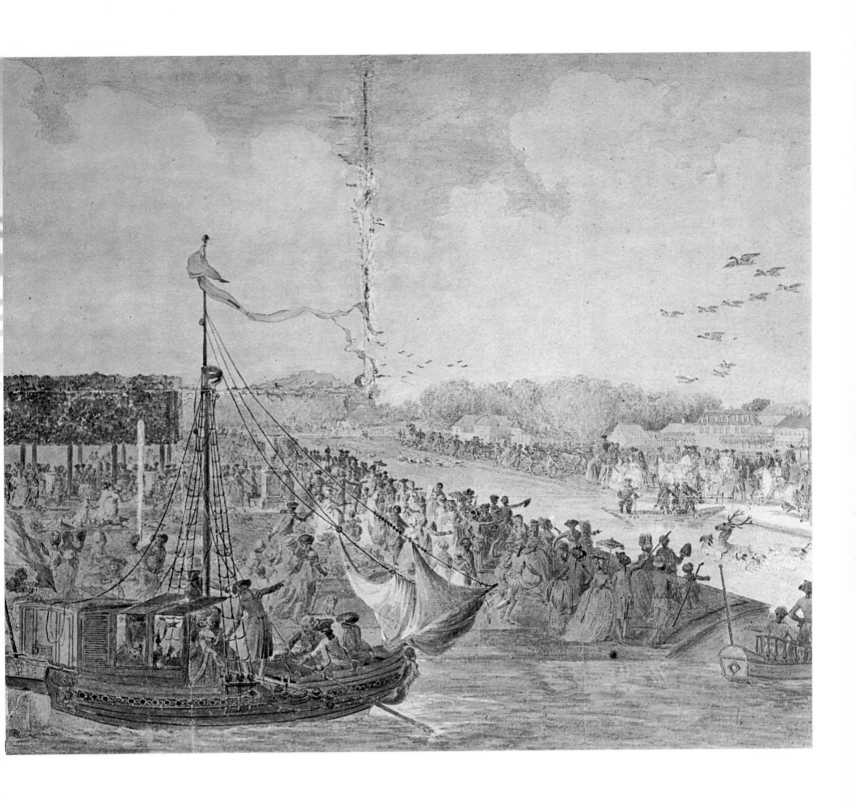

Hubert Robert: *Design for the Theater Built at Versailles in 1785*. Watercolor on paper, $11 \times 38\,{}^9/_{16}$ in. (detail). Archives Nationales, Paris.

Hubert Robert, who had enjoyed a good education, was a very cultivated man with a vitality that astonished his contemporaries. To appreciate his talent one must remember the extent of his literary and archaeological interests and also one or two of his exploits. As a young man, companion to Fragonard in Rome, he scaled the dizzy, unsafe heights of the Coliseum to the amazement of his friends. During the Revolution, because of his devotion to the former sovereigns, he was imprisoned in Paris where he not only kept up the morale of other prisoners by organizing poetry recitals and games, but even continued to practice his craft: he painted landscapes and scenes in watercolor on the prison plates and the jailers sold them. A favorite with Marie Antoinette, Robert was not content only to paint pictures for his Queen. He designed gardens, and when the Queen, who was passionately fond of drama, decided to construct a small theater in a wing of the château, Hubert Robert, who was also an architect, was commanded to draw up the plans and oversee the construction. Instead of impersonal sketches or elevations, he presented his conception of a new theater for the Queen in watercolor, and won her immediate approval. This room devised by a painter must have been charming, but as it was built only a few years before the Revolution it was used for only a short time. Versailles was occupied after the fall of the Monarchy, during the Empire and the Restoration. In 1830, when the château was transformed into a museum, the little theater was thought to be superfluous and was destroyed. Nowadays visitors enter the château of Versailles through great, empty halls on the exact site of Hubert Robert's theater, so charmingly presented in this watercolor.

Pierre-Joseph Redouté: *Podalyre*. Gouache on parchment, 17³/₄ × 12¹/₄ in. Signed on the border: *Redouté*. Bibliothèque du Muséum d'Histoire Naturelle, Paris.

At the beginning of his career Pierre Redouté, a pupil of Van Spaendonck, painted many gouaches on vellum, in the manner of those illustrated here, of the flowers of the Royal Garden. They were intended to form a collection of plant illustrations, and they have preserved for us meticulously exact representations of the finest specimens grown each year. Redouté's great success was partly due to the growing fashion for gardens and fresh flowers in the reign of Louis XVI. At that time the classic architecture of the French garden, inherited from Le Nôtre, with its fountains, dells, and lawns, was replaced by a much smaller garden of varying shape and decoration, laid out with numerous flower beds and occasionally with greenhouses, vegetable gardens, and collections of rare plants. At the same time, as is evident from portraits and interiors, the enjoyment of fresh flowers of all kinds increased. Marie Antoinette's contemporaries were struck by her desire to be surrounded by fresh flowers, which generally came from her own garden. Flower painting in France developed a new character. Redouté understood botany as well as drawing and watercolor. He aimed at precision rather than effect, and was prepared to specialize in order to become official painter of the Queen's roses. For Redouté watercolor was like handwriting, a means of recording the finest successes in the world of plants and of examining the secrets of evolution and natural change.

Jean-Baptiste Huet: *Lovers' Meeting* (1786). Pen and watercolor on paper, $9\,{}^{1}/_{16} \times 17\,{}^{1}/_{16}$ in. Signed: *J. B. Huet 1786*. Private collection.

Jean-Baptiste Huet was a prolific artist who handled many different subjects, though all were inspired by nature. He painted animals, flocks of sheep, and trophies of the hunt. Gardening became very fashionable in the reign of Louis XVI, and many nobles laid out the plans for their gardens themselves. Tending flowers was turned into a refined amusement. But there were subtleties in the interpretation of symbols represented by plants or by the simplest human posture. Steeped in mythology, the eighteenth century enjoyed the language of flower and gesture. Huet's figures tending their garden present a scene full of hidden implications, but the key to this amorous story escapes us. The drawing is schematic. The water is curiously indicated by pen. The colors are subdued. The painting's subtlety of purpose is belied by the seeming naïveté of its expression. At the people's feet is a cord resembling a distaff. It is an ambiguous symbol of gardening and of the ephemeral nature of life and sentiment.

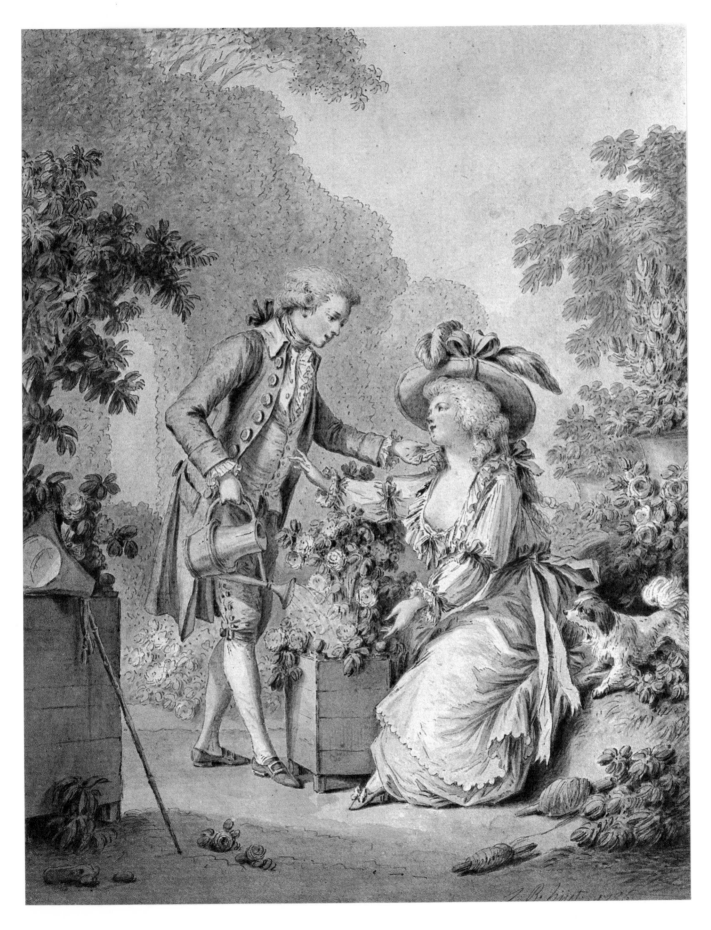

Jean-Baptiste Mallet: *The Happy Family*. Gouache on paper, $16^1/_2 \times 12^5/_8$ in. Private collection.

Baudouin, Lavreince, and Mallet painted for the same public, and their techniques are completely comparable, but the ways they developed their subjects and the differences in their styles reveal the tremendous change in outlook that evolved between 1760 and 1790. Baudouin, for instance, turned classical myths into anecdotes of everyday life. For Lavreince the realism of an existence stripped of the spice of indiscretion and the unexpected was enough to attract the eye. For Mallet virtue and moral tone added to the attractions of the painting. But the triumph of moral sentiment is not linked with artistic quality. Mallet's watercolor technique is inferior to that of Lavreince, who was himself surpassed by Baudouin. Mallet remains a delightful painter, especially in his taste for precise detail and his sense of color. His vivid paintings sometimes suffer from being a trifle too geometric and from a rather touching awkwardness. Some daring watercolors by Mallet and even by Lavreince are known, but Mallet generally preferred virtuous family reunions, and in this watercolor Cupid dominates the appealing group of mother, father, child, and dog gathered around the fireplace. The atmosphere of Republican morality extolled at the onset of the Revolution was already here. Toward the end of the century Mallet became a panegyrist, in his oils and watercolors, of Greek and Roman virtues.

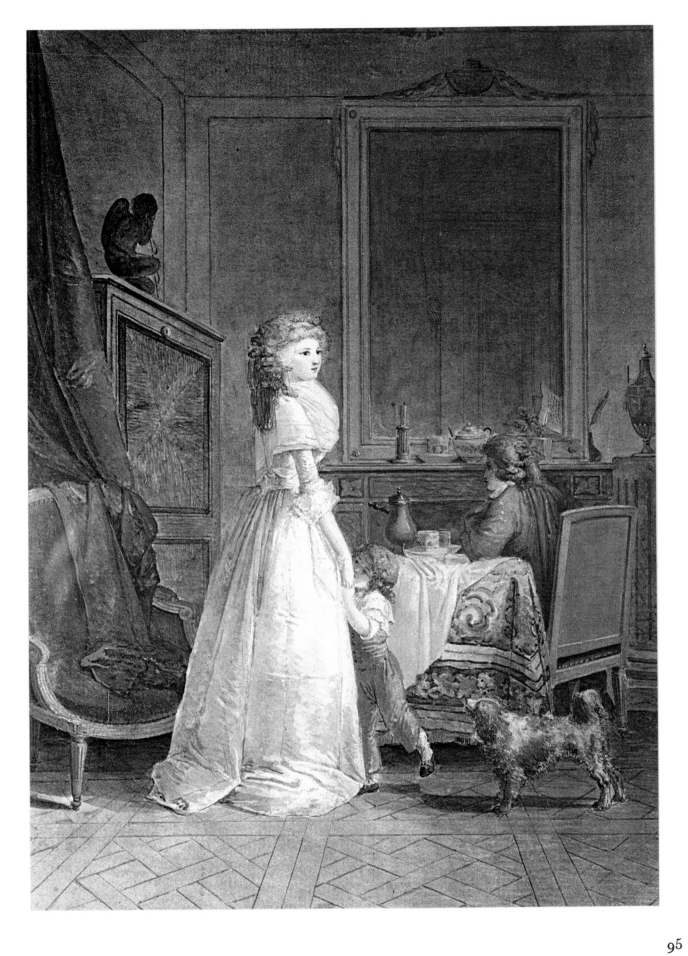

Claude Martin de La Gardette: *The Pavilion of Venus and the Temporary Pavilion Erected for the Fêtes held in Honor of the Visit of the Comte du Nord in the Park at Chantilly*. Watercolor on paper, $10^5/_8 \times 15^3/_4$ in. (detail). Signed: *de la Gardette 1787*. Private collection.

The watercolorists were journalists, with more or less success, of the late eighteenth century. In a society which felt itself obscurely threatened, *fêtes* and happy occasions multiplied. Time was often too short for stone sculpture or for painting beautiful mementos in oil, and so the young architect Claude Martin de La Gardette was commissioned to make an album of watercolors recording the *fêtes* given in the grounds of the park of the Prince de Condé at Chantilly. Descendants of the conqueror of Rocroi, an extremely rich and noble family who lived slightly apart from the court, the Condés had cherished for a hundred years a garden designed by Le Nôtre. It was considered to be one of the finest in Europe. The first Chinese garden, the first rustic hamlet, had been created at Chantilly. *Fêtes* held there were sumptuous. At such times temporary pavilions were erected, such as the one shown here by La Gardette, built for the visit of the Comte du Nord, the future Tsar Paul I. Although La Gardette is careful to record proportions and design exactly, he enjoys enlivening and brightening each picture. There are swans, people stroll on the paths, the sky of the Ile de France is blue with scarcely a cloud in sight. The watercolor has all the exciting and disturbing instability of fireworks.

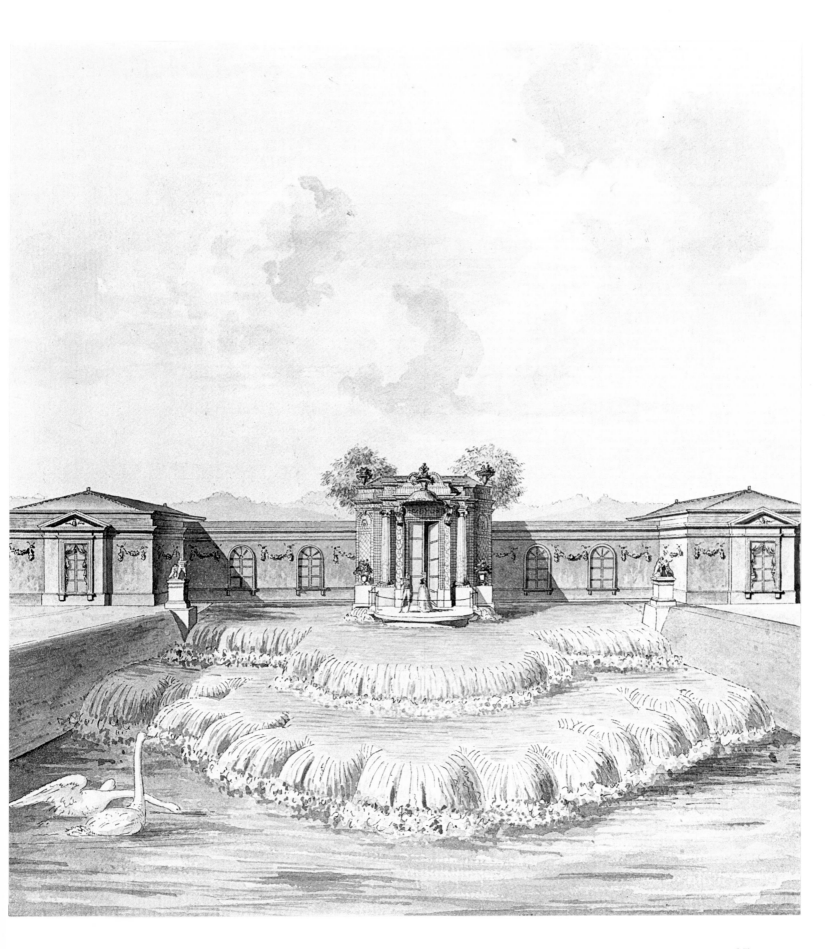

Louis-Philibert Debucourt : *The Broken Ewer* (1787). Watercolor and gouache on paper, 11 $^{13}/_{16}$ × 9 $^{13}/_{16}$ in. Musée des Arts Décoratifs, Paris.

Louis-Philibert Debucourt was a master of chaste eroticism, an ironic champion of a theatrical and realistic popular taste. Working during the Revolution, he underlined some of its more amusing ambiguities and reconciled in his own way Robespierre's ambitious crusades for the regeneration of humanity and the extreme lack of constraint of *Thermidorien* society. Of course, unlike the painters of the *ancien régime*; he showed no lovers in bold poses; the gardener throws himself chastely at the feet of his shepherdess. But the broken ewer is not symbol enough, as it would have been with Greuze. Debucourt is not satisfied with a symbol, however obvious. The grass is crushed and a shoe lies abandoned, at the right behind the lovers. A white sheep bleats his consolation; beautiful sentiments efface the apparently irreparable damage, and the open bodice adds piquancy to the composition. An artist who was serious, precise, even a little cold, Debucourt drew with more spirit than he showed in his choice of color, which is often dull. He was an engraver as well as a watercolorist, and handled the burin with greater skill than the brush. But it was in watercolor that he created his compositions.

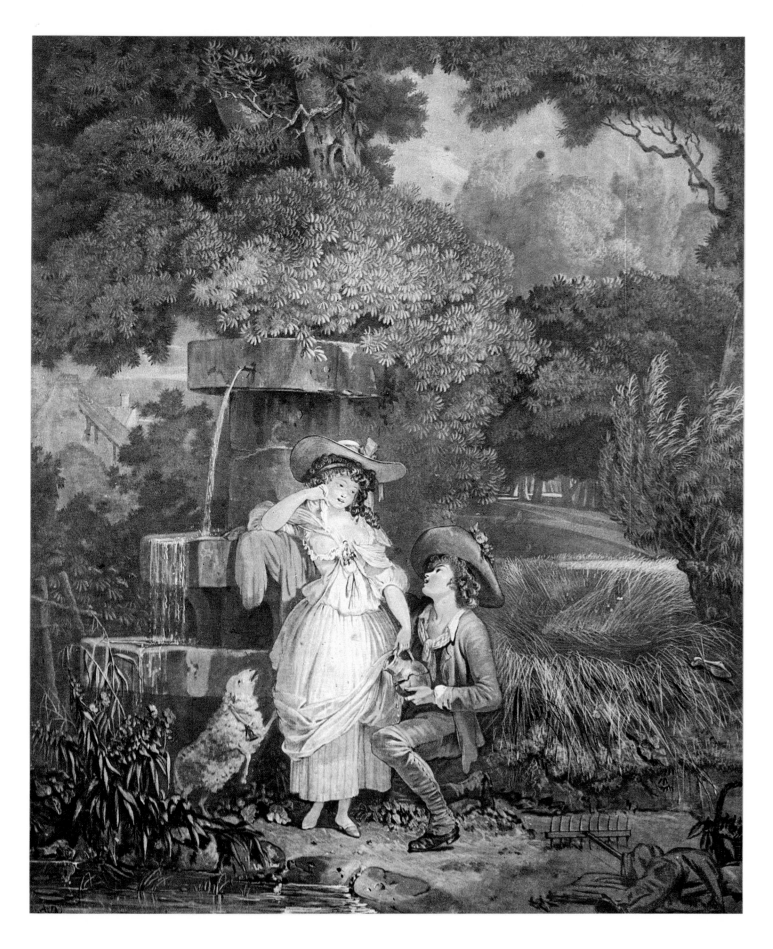

Pierre-Antoine Demachy: *The Demolition of the Convent of the Franciscans*. Gouache on paper, $11\,^3/_8 \times 16\,^1/_8$ in. Musée Carnavalet, Paris.

The work of Pierre-Antoine Demachy exemplifies the transition between the simple landscapes in gouache or watercolor typical of the early eighteenth century, very few of which remain, and the real and spontaneous, truly pictorial works which were the joy of the collectors just before the Revolution. Demachy was principally a gouache painter, but learned watercolor technique from his Italian master, Servandoni, the architect of Saint-Sulpice, whose own watercolors are unknown. Demachy was precise and careful. His style resembles that of the Italian landscape painters, but his work is lifeless. He was undoubtedly a painter who worked in his studio. His work offers a conscientious representation of Parisian streets, monuments, and costumes. The success he enjoyed until he was very old indicates that there was a large public for these precise pictures, which renewed and improved upon a popular tradition. But his freshness of tone and variety of approach could not disguise the artificiality criticized by Diderot. Demachy was essentially a traditional painter.

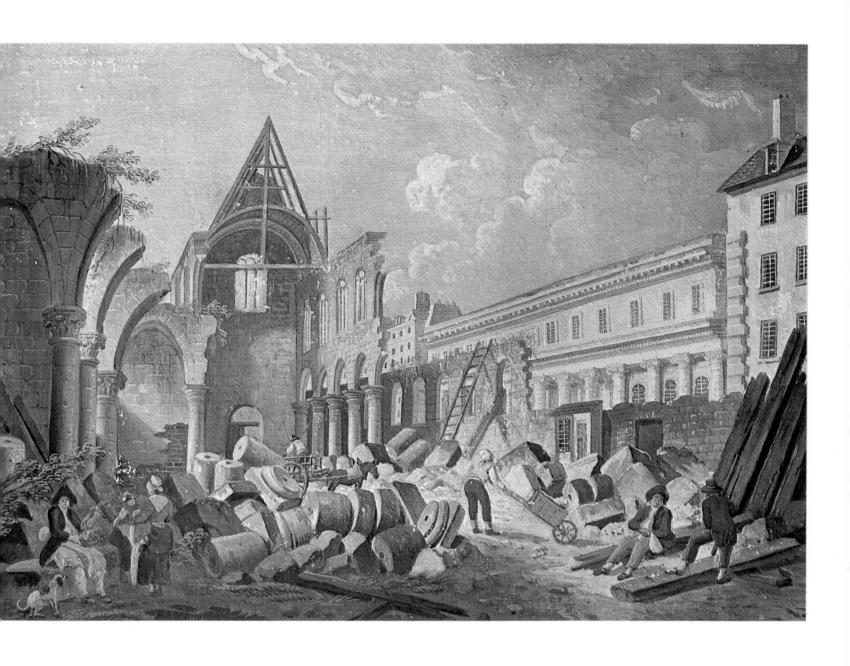

Jean-Baptiste Lallemand: *The Boulevard*. Gouache, $7\,^1/_{16} \times 9\,^1/_{16}$ in. (detail). Print room of the Bibliothèque Nationale, Paris.

It was during the reign of Louis XV that the Paris theaters were established on permanent sites. The Opéra, the theater of the Comédie Française near the Palais-Royal and its supplementary quarters in what became the Odéon, were not to move out of their district or these buildings again. Private theatrical undertakings, unlike the Opéra, the Opéra Comique, or the Comédie Française, were principally installed on the boulevards, where they are nearly all still to be found today. This was not accidental. The boulevards represented the farthest limits of Paris in the early eighteenth century. There were the monumental gates, some of which still exist, the fortifications, and the open spaces necessary for maneuvers of the army or the special militia. Despite their military purpose the boulevards were a fashionable place to walk, and the theatrical entrepreneurs preferred to build their theaters there, usually of flimsy materials. Most of the great theatrical halls of the nineteenth and twentieth centuries were built on the same sites. Jean-Baptiste Lallemand was a provincial artist who had probably observed and painted the daily events of the street all his life. His sojourn in Paris at the end of the century makes him a valuable witness of a period not noted for calm. The abbey on the right helps us to date this charming scene at 1790 at the latest. Dogs, riders in uniform, a woman accompanied by her maid, a street porter, and a noble or bourgeois couple all mingle with a milling crowd before the doors of a theater. Lallemand practiced watercolor freely. He painted without preliminary drawing, and the incisive lines of his brush contribute to the vitality of his work.

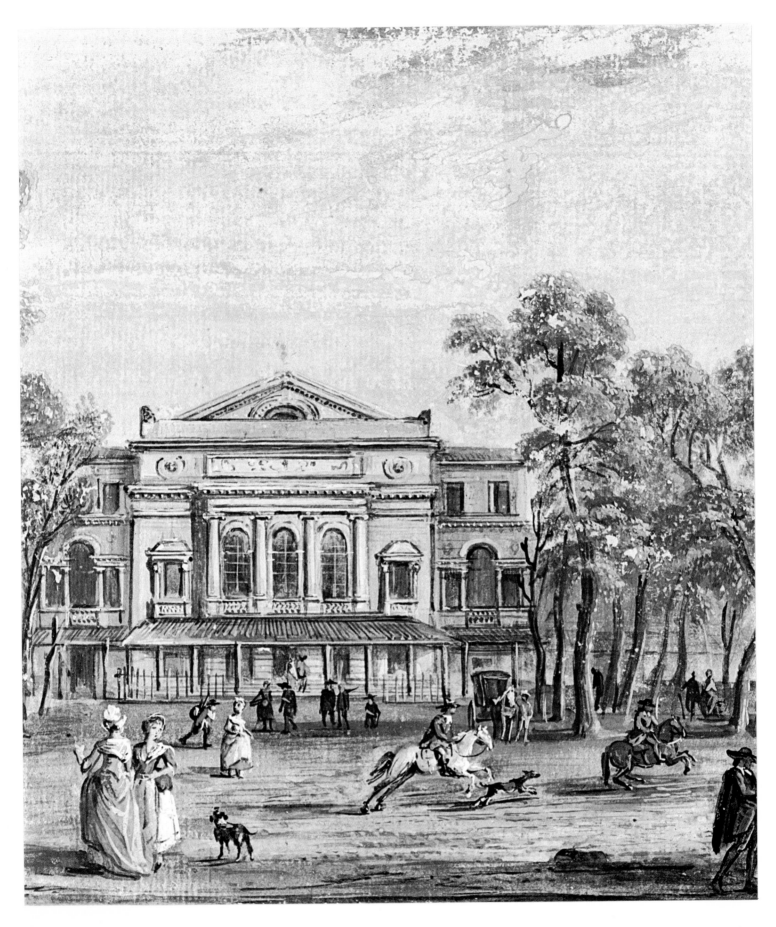

Jean-Baptiste Hilair: *Picking Oranges in the King's Garden* (1794). Gouache on paper, $6^{11}/_{16} \times 9^{7}/_{8}$ in. (detail). Signed: *Hilair 1794*. Print room of the Bibliothèque Nationale, Paris.

Jean-Baptiste Hilair knew how to make the most of the gaiety of watercolor. He was not an adroit draftsman or a faithful landscapist. His figures are often very simply done, and one cannot entirely trust the scenes he represented because when he felt like it he did not hesitate to modify or alter the motif. But he attained a perhaps deeper sincerity through his talent for playing with the fresh contrasts of watercolor, and because of his wonder at the world about him. In the time of Hilair, whose works are often dated after 1790, watercolor seemed to be a genre linked with specific subjects and with a way of painting reality which was totally different from oil color. His watercolors, with a bias which is certainly not accidental, ignore the riots, massacres, and battles of the Revolutionary period. The artist seated on the left is still wearing stockings and breeches in the style of the *ancien régime*. But the young man leaning on the ladder is a "sans-culotte," that is, one wearing trousers. Characteristic of Hilair's style was the theme of the revolutionary picking oranges instead of fighting; another water-color shows him bathing nude in the river. At a time when oils were reserved for historical paintings, Hilair used watercolor to depict familiar and pleasant happenings. He was an illustrator who tried all effects and mixed black ink with his colors, but was also a true watercolorist who took full advantage of the white background to illuminate his composition.

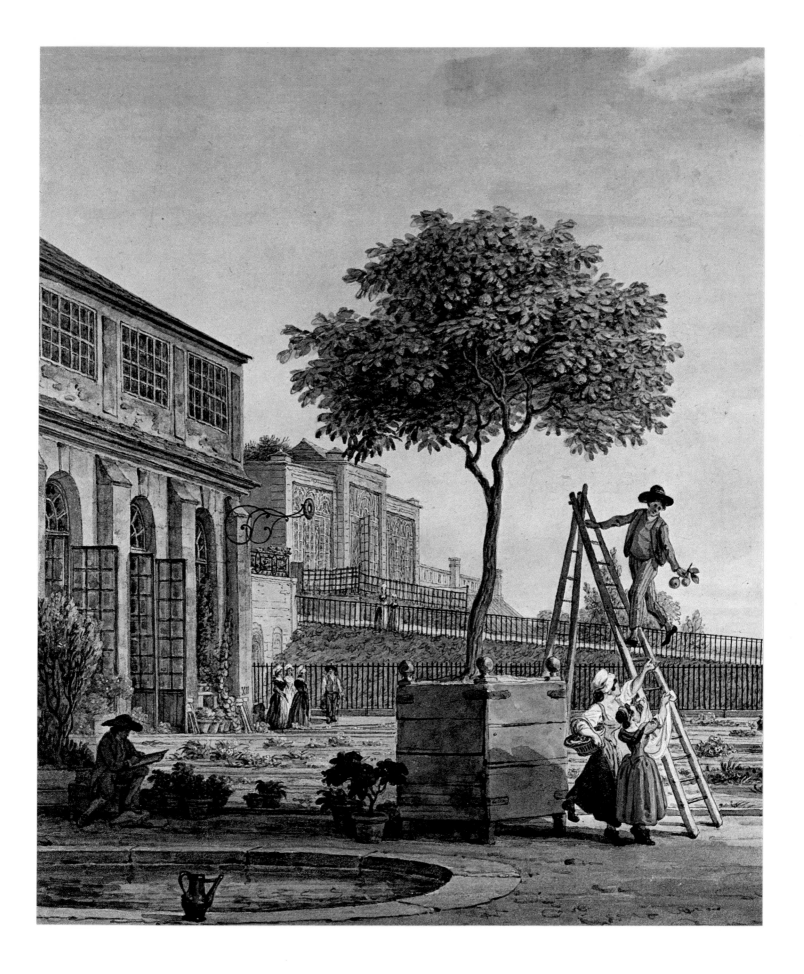

Jacques-Louis David: *Design for Symbolic Costume* (1794). Pen and watercolor on paper, $12\,^3/_{16} \times 8\,^5/_8$ in. Initials of the two sons of David. Musée Carnavalet, Paris.

Nothing was more alien to Jacques-Louis David's temperament than watercolor. This passionate artist looked upon art as a religion and tried to make his paintings of antique philosophy and morals seem as convincing as possible. Neoclassicism was a dogma for him, and he enjoyed expounding heroism, virtue, and beauty. David rejected spontaneity and tried to produce long-meditated works inspired by Greek or Roman literature or sculpture, yet done from life. But when he looked at a landscape and ingenuously noted his emotions; when he sketched out a project and was inspired by a passion he could no longer control, David became a watercolorist despite himself. Drawn into political battles by his artistic convictions, and a member of the Convention, David had the difficult task of creating new French uniforms which would harmonize with the ideas of classicism and virtue representative of the Revolutionary period. Forced, like the scene painters, to do these in watercolor, David unexpectedly became one of the numerous watercolor painters of the late eighteenth century. However, his technique and temperament are still revealed in this, for him, unimportant exercise. He drew his figures with a strong ink line, and his color and shadow have the vigor of an oil. He used the white of the paper very little and disregarded the transparency, the elegance, which then characterized French watercolor. This studied work heralded the violent and rude realism of the painters of the following century.

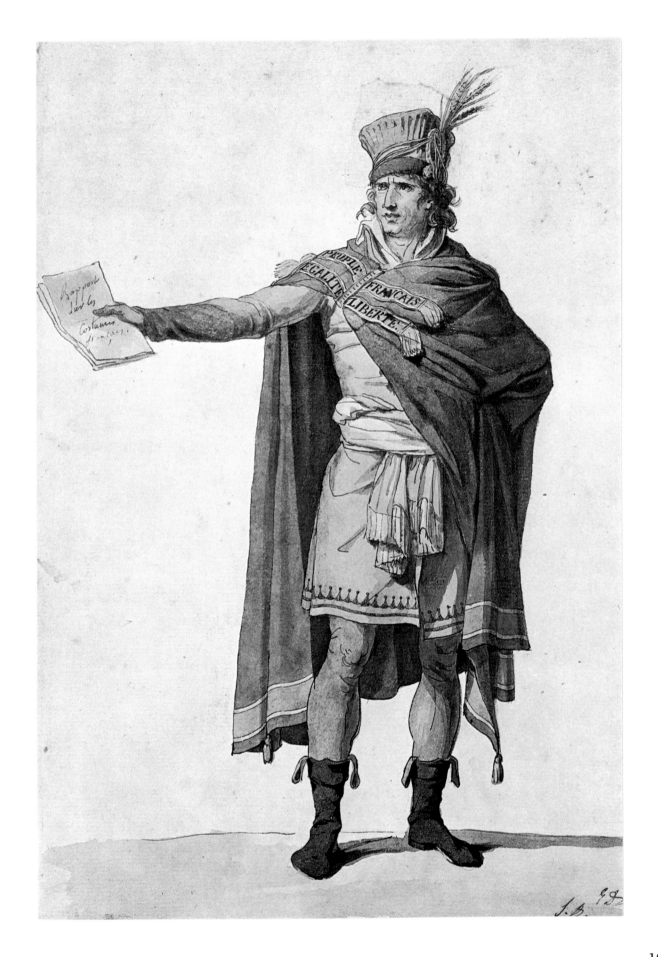

107

Louis Watteau de Lille : *The Wretched Poor* (1795). Pen and ink and watercolor on paper, $12\,^3/_{16} \times 9\,^1/_{16}$ in. Signed : *95 W*. Private collection.

Louis Watteau de Lille, like his uncle, the great Antoine Watteau, possessed an extraordinary ability to observe the smallest details of daily life. He was a faithful observer of troop movements, encampments, and street scenes of the frontier province in northern France where he was born and spent the greater part of his life. He did not try to reveal the sentiment, the emotion, the illusion in a face or a landscape. His drawing is careful but does not have the same evocative and restrained simplicity displayed by his uncle. This serious watercolor was first executed in ink, like a drawing, to indicate outlines. Then color was added, sometimes in the form of tiny splashes, sometimes in large brush strokes. Undoubtedly this is a scene in Lille in wartime during the French Revolution, when the frontier towns suffered periods of real poverty. Watercolor was the most appropriate technique for reporting the disasters of war. Louis Watteau must have painted this on the spot; his cardinal virtue is that he was a straightforward witness. Although he represented events as they happened, Watteau de Lille was able to describe what he saw simply and with talent.

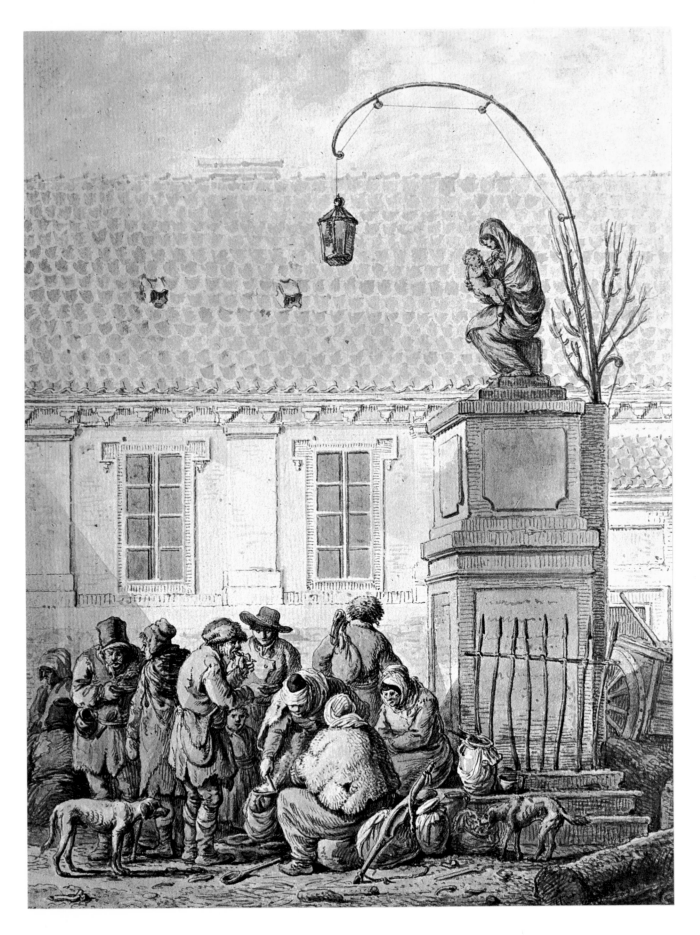

Louis-Pierre Baltard : *The Colonnade of the Louvre and the Institute Seen from the Terrace of the Hôtel d'Angiviller* (on the present site of the Rue de Rivoli). Paper, $14^1/_8 \times 19^1/_{16}$ in. (detail). Private collection.

During the eighteenth century the Louvre was still enclosed by buildings which prevented a full view of the palace and actually hid several of its façades. Only the Grande Galerie facing the Seine had an open view because a busy street separated it from the river. The present Place du Carrousel was occupied by a whole district of Paris with many important buildings, and the Cour Carrée, despite royal decrees, was always invaded by temporary structures which reappeared after every demolition. By the end of the century, the colonnade built by Louis XIV in the classic style which suited the taste of the period was freed of many of the houses surrounding it. The present-day Rue de Rivoli did not exist. In its place, and level with the colonnade, was the house and garden of the Comte d'Angiviller, Superintendant of Buildings for Louis XVI. The terrace of the house overlooked the foot of the colonnade, and as the houses had been cleared away, there was a new vista as far as the Left Bank of the river. The costumes enable us to date this watercolor at the end of the Revolutionary period. This is an architect's drawing with schematic forms used to underline a perspective, but Louis-Pierre Baltard was influenced by the watercolorists of his time, and could not resist enlivening his composition by adding trees and people. Thus, by the end of the century, an architect's design became, through the change in the conception of watercolor, the work of a landscape artist.

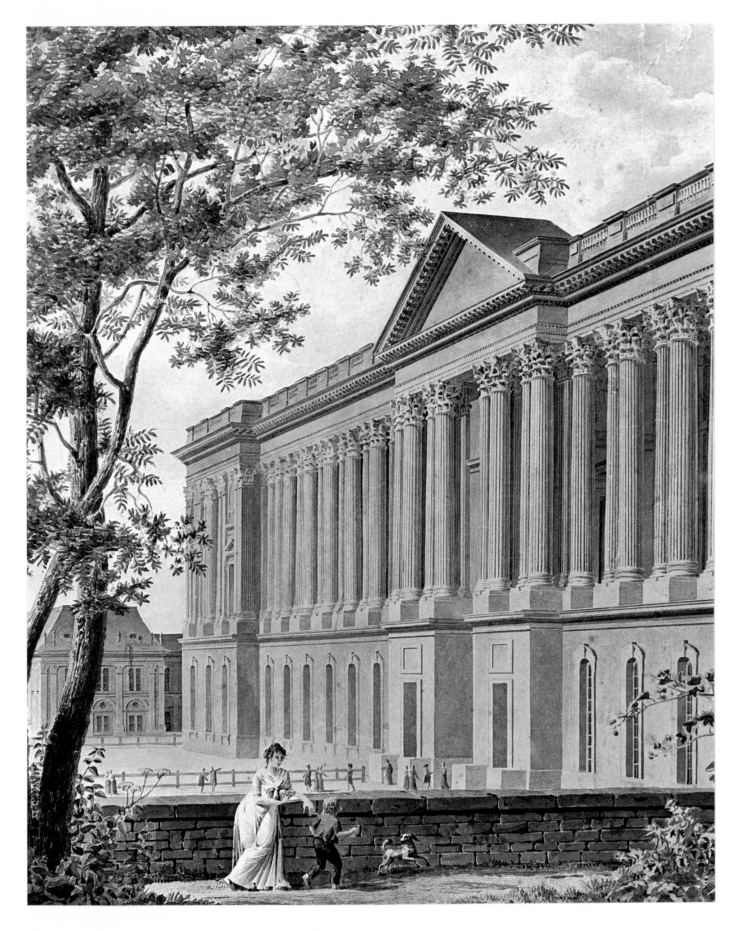

THE TECHNIQUE
OF
WATERCOLOR

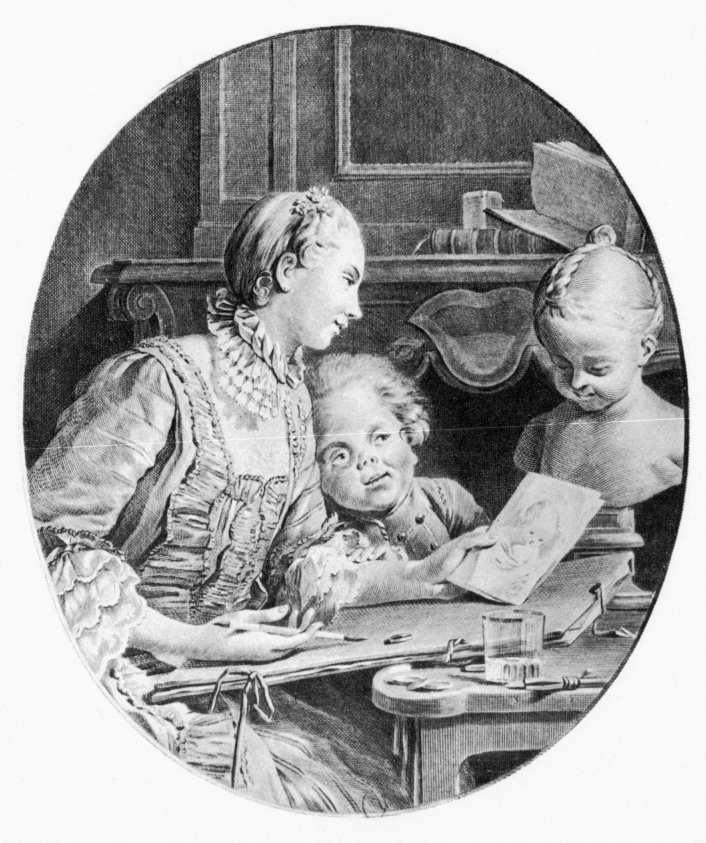

Engraving of Hallé (1761)

Watercolor painting is not defined in any dictionary or technical guide of eighteenth-century France due to a simple linguistic circumstance—the late appearance of the word *aquarelle*. The technique did exist, but is described in several works under the heading of gouache or wash. Of course a gouache, and even more a miniature, does not look like a watercolor; and a wash really ought to be classified with drawings. Nevertheless no distinction was made between color-drawing, wash, watercolor, and pure gouache; this quadruple modern distinction was at once a reality and an anachronism in the eighteenth century. At that time art historians distinguished only between drawing and watercolor painting.

According to twentieth-century standards, when line is enriched with color, so long as it remains transparent we are still in the realm of watercolor. Gouache is indeed a painting done with water, but it is opaque. The same colors mixed with the same fixative can be used in transparent or opaque tones, depending on the degree of dilution—in the eighteenth century the fixative was gum arabic, the resin of the acacia. In modern practice, in gouache painting a small quantity of white lead is usually added

The illustrations on pages 117, 119, 121, 123 are selected from the Encyclopédie *of Diderot and d'Alembert. The vignettes reproduced intext are details of engravings, also dating from the eighteenth century.*

to each color; at the moment of use, the paint has a viscous appearance resembling oil paint. Water-colors, on the other hand, are either liquid or solid; in the latter case the brush, heavily charged with water, mixes the required amount of color for each stroke.

The miniaturist uses viscous color, consequently gouache, and yet his work is so delicate that, like the watercolor painter, he preserves the transparency of the colors, and these are brightened and changed by the usually light-colored ground.

The confusion is explained by the absence, in the eighteenth century, of any theoretical instruction in the technique of painting. Of course there were history-of-art courses, but they were very biased; long before David the Italians were the Olympians and the Flemish considered a dangerous precedent. The schools also lectured on great classical art; Greek and Roman mythology as gleaned from Homer and Ovid; physical representation and the traditional symbolism of noble feelings and passions. The artists cast off this weight of academic learning as soon as possible and contrived to forget everything except the essential aspect of their art—the manual side—preferring to learn from daily contact with a master, and at first hand. All the best painters of the day felt that they ought to have the right to use whatever methods seemed to contribute to their success. These very individual craftsmen were living at a period when experiments and scientific discovery were extravagantly popular even in the highest society.

Although preparation of the artist's materials was of course considerably less industrialized than it is today, there were many more prepared colors than there were under Louis XIV. But every painter had to master a technique of his own, just as the twentieth century invents and strives to be original in other ways. For instance, the excellent method invented by Quentin La Tour to fix his pastels is still unknown, as are the equally complex, but very different, methods employed by Watteau or Chardin to lend mystery and profundity to their painting. Louis Moreau, Saint-Aubin, Hubert Robert, Frago-nard used such a personal technique in watercolor and gouache that the ease with which they can be identified adds to their appeal. Failing a detailed definition of all their individual methods, it is of interest to read the description of a competent contemporary, Watelet—member of the French Academy and

PEINTURES EN HUILE, EN MINIATURE ET ENCAUSTIQUE,

PLANCHE Iere.

VIgnette. Cette vignette repréfente un attelier dans lequel on a tâché de réunir plufieurs genres de peintures.

La *fig.* 1. repréfente le peintre d'hiftoire. *a*, fon marche-pié. *b*, le pincellier ou grande boîte à couleurs. *c*, pierre à broyer les couleurs.

La *fig.* 2. repréfente le peintre de portraits. *d*, fa boîte à couleurs.

La *fig.* 3. repréfente un peintre occupé à réduire un tableau dont il veut faire une copie. *e*, le tableau qui lui fert de modele. *f*, la toile fur laquelle il a tracé autant de carreaux qu'il en a fait fur celui qu'il fe propofe de réduire (ou de copier).

La *fig.* 4. repréfente le peintre de portrait en miniature.

On apperçoit dans le fond de l'attelier deux figures antiques, un globe, une équerre & des livres qui font autant de chofes utiles aux peintres, & qui défignent l'étude des antiques, l'hiftoire, la géographie & l'architecture.

Bas de la Planche.

Fig. 1. Appui-main. 2. 3. & 4. Couteaux de différentes formes.

5. & 5. Broffes.

6. Bléreau dont on fe fert pour fondre les couleurs.

7. 8. & 9. Pinceaux.

10. 11. & 12. Palettes de différentes formes.

PLANCHE II.

Fig. 1. Boîte à couleurs.

2. Coupe de cette boîte.

3. Son plan.

4. Boîte de fer-blanc pour contenir les pinceaux & les veffies. *a*, le pincelier. *b*, quarré pour mettre les veffies. *c*, quarré dans lequel on met l'huile d'olive pour détremper les pinceaux.

5. Coupe du pincelier.

6. Coupe du quarré qui fert à faire tremper les pinceaux.

7. Autre boîte de fer-blanc pour mettre les couleurs en poudre.

8. Veffie pour mettre les couleurs brouillées.

PLANCHE VII.

Uftenfiles à l'ufage du peintre en miniature.

Fig. 1. 2. & 3. Différentes palettes d'ivoire.

4. & 5. Petits pots d'ivoire pour mettre les couleurs, & que l'on renferme dans une boîte d'ivoire.

6. Différentes fortes de pinceaux.

7. 8. & 9. Trois fortes de couteaux qui fervent à broyer les couleurs.

10. Forme de palette dans laquelle font creufés différens trous pour contenir les couleurs.

11. Loupe.

12. Pierre à brouiller les couleurs.

13. Boîte d'ivoire pour mettre les petits pots à couleurs.

14. Boîte pour renfermer tous les uftenfiles du peintre, lorfqu'il va en ville.

15. Pierre de ponce.

the Academy of Painting—in his *Dictionary of the Arts*, published in 1792, under the heading *Gouache, or Gouazze*, page 431. For Watelet, gouache comprises what we understand by the two separate terms, watercolor and gouache.

"The style of painting described by this word is one of the oldest we know, if it is not indeed the one that preceded all the others. Water is undoubtedly the easiest and most natural method of rendering powdered colors fluid, so that they can be spread and will adhere to a surface. The first colors were probably earth and crushed stone, rendered into liquid with water as a medicine; but in practice it was found that when the water had evaporated the colors did not adhere, but flaked off the surface, so an attempt was made to give them consistency by adding a form of glue; there were gums, produced in abundance on certain trees, which dissolved easily in water and, being transparent, did not change the colors, and these seemed ready-made for the purpose. Gouache is nothing more than this simple preparation of colors crushed and mixed with water and charged with a greater or lesser solution of gum.

"The colors, thus prepared, are used on many different foundations: canvas, vellum, paper, ivory. Generally gum arabic is used for gouache painting, as it was in miniatures, because it melts easily in the water after it has been mixed to the desired strength with different colors. These colors are laid and overlaid—put on thickly so as to give them body, which of course is not the case with a wash or miniature. Some colors demand more gum than others: experience dictates the rules in this regard, and overcoming the difficulties helps to establish them.

"One difficulty is that colors mixed with too little gum will powder away when they dry or are rubbed. On the other hand, if they have too much gum they scale, split, and flake off. Simple experiments are a better guide than anything one can say on the subject.

"Gouache is very suitable for painting a landscape and is useful for sketches for large compositions. It is used for theatrical sets, festival decorations, and for plans. This style of painting is quick and expeditious and has a certain brilliance. One should, however, be on one's guard against drying, because these colors dry so quickly that one cannot overpaint as much as one might desire."

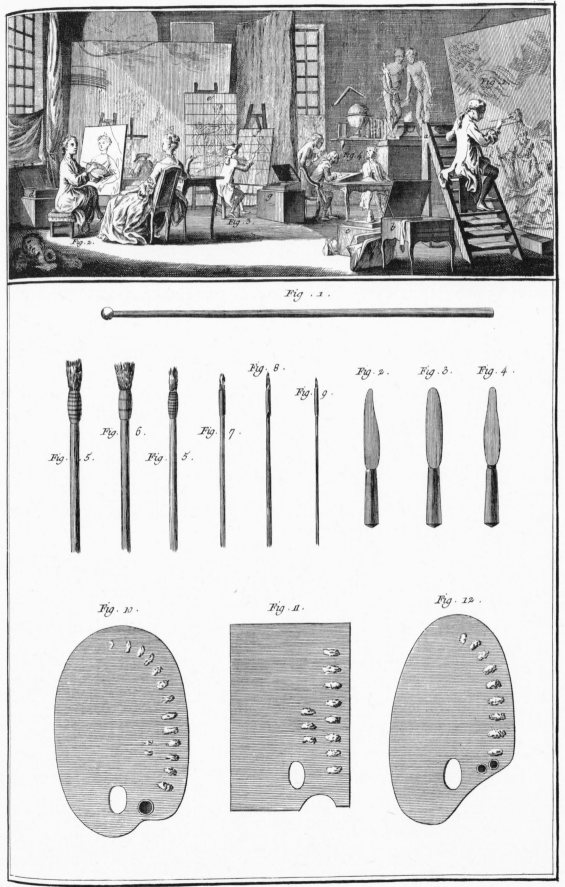

Pl. I.

Fig. 1.

Fig. 5. Fig. 6. Fig. 5. Fig. 7. Fig. 8. Fig. 9. Fig. 2. Fig. 3. Fig. 4.

Fig. 10. Fig. 11. Fig. 12.

One work which went through several editions gives amusing instructions about how to procure and use the colors. Entitled *Rules for Drawing and Wash* and written by Buchotte, it is a collection of recipes and sound advice, clearly set out. The preparation of watercolor is very well explained:

"Carmine, ultramarine, vermilion, and Prussian blue should be mixed with water and gum, preferably with the finger in a small faïence pot, or in a shell, always making sure that neither the finger nor the vessel are greasy or dirty.

"However, as carmine and ultramarine are quite expensive and the amount left on the finger is so much lost, I use a small ivory stick for these two colors. About three or four *lignes* in diameter, it is flattened at both ends and one end is used for carmine, the other for ultramarine. It should be remembered that only a small amount should be prepared at one time, especially of the carmine, because it darkens as it is mixed and becomes the color of ox-blood. As soon as one stops working the colors should be wrapped in paper and enclosed in a box, because the air spoils them and dust makes them dirty."

Buchotte also suggests a design for a paintbox which, with variations, must have been widely used.

"You should have about twelve little faïence pots to put the colors in; they should be about two inches in diameter and about nine *lignes* deep at the most, with a straight edge, not everted as in a pommade pot, for reasons that will be obvious to the user. It is also necessary to have three or four small glass bottles, about two inches in height, to contain liquid bister, the watercolors, and the gum-water. To hold the paints, pots, brushes, pens, pencils, needle-case, penknife, and so on one should have a slim box about three lignes thick, as follows: First, the inside of the box is divided into eight compartments. Four compartments are seven inches long by two and a half wide and one inch deep, fixed to receive the twelve small faïence pots. Four are one and a half inches wide by two inches deep, the depth of the whole box. Of these last four compartments two can be used for holding the bottles and the two others for other materials."

And finally he indicates the best shops where our ancestors could find the materials necessary for watercolor painting, and includes the prices of the day. It is possible to calculate the eighteenth century

Pl. II.

fig. 2.

fig. 3.

fig. 5.

fig. 7.

fig. 1.

fig. 8.

fig. 4.

fig. 6.

Pieds

livre roughly at the rate of the dollar today. The *sol* is then worth twenty-five French *centimes*, or five cents. The French ounce was the equivalent of thirty grams and the *gros* of four grams. All the streets listed by Buchotte still exist today in Paris.

"Although the price of materials is subject to variation due to the contingencies of the time, I will give some of the relevant ones here, despite the fact that several colors have become extremely dear, especially ultramarine.

First, the colors :

Carmine ranges from forty *sols* ($ 2.00) the *gros* (4 grams) to as much as 3 *livres* ($ 3)

1 ounce of gamboge	10 *sols*	(2.50 frs.)
1 ounce of sap green	10 *sols*	(2.50 frs.)
1 ounce of finest vermilion	4 *sols*	(1 fr.)
1 ounce of aquamarine	4 *sols*	(1 fr.)
1 ounce of whitest gum arabic	18 *sols*	(4.50 frs.)
1 shell of verdigris	5 *sols*	(1.25 frs.)

Cake or stick of Chinese ink, two inches long, about nine lignes wide and three thick, made in Holland or Paris, ordinary, 5 *sols* (1.25 fr.)

And the best, 10 *sols* (2.50 frs.)

The kind which really comes from China, same size as above, 1 *livre* (5 frs.)

And the finest, 1 *livre,* 10 *sols* (5.50 frs.)

A dozen medium brushes 18 *sols* (4.50 frs.)

All these colors and materials are to be had at :

A la Cornemuse, Rue Greneta.

A l'Etoile d'Or, same street.

And au Cerisier, same street, opposite the Charriot d'Or.

"Regarding brushes, the sieur Doucelin in the cul-de-sac of the Rue de Jouy offers them at the rate of 18 sols (90 cents) the dozen.

"The best brushes are made by Bonair, Rue du Roulle, at the corner of the Rue Saint-Honoré, at a fashion merchant's shop, on the fourth floor ; but they cost eight *sols* each ; five years ago they were only six *sols*."

fig . 3 .

fig . 2 .

fig . 1 .

fig . 5 .

fig . 4 .

fig . 10 .

fig . 9 .

fig . 7 .

fig . 8 .

fig . 6 .

fig . 13 .

fig . 11 .

fig . 12 .

fig . 14 .

fig . 15 .

A comparison is easy to make between the price of colors then and two centuries later; about 1.75 francs for 30 grams or the ounce, that is, about 35 *sols* the ounce in 1968. Prices have certainly not continued to increase with the contingencies of the time, but rather diminished, though it must be admitted that one cannot compare the industrial products of today with the subtle handmade colors of the eighteenth century.

Watercolor, justifiably considered practical, popular, and cheap in the days of Marie Antoinette, nevertheless appears to us in retrospect more complex and costly at that time than it has since become. Technical and economic progress has helped to spread this method of painting to a far wider public, but it has unfortunately not always inspired an equal flowering of artistic talent.

BIOGRAPHIES

V. ANTIER

There are no documents covering the life of this artist, but several of his views of Paris, done in the early eighteenth century, are now in the Musée Carnavalet.

LOUIS-PIERRE BALTARD
1764–1846

Painter, engraver, and architect, Baltard was a native of Lyons who displayed the eclectic taste and overflowing energy of so many eighteenth-century artists. He was a pupil of Bachelier in a private school of design and engraving and subsequently learned architecture with Mique, Peyre, and Ledoux. At the age of twenty he was already making drawings after classical art for a book; he stayed for a year in Italy where he painted monuments and landscapes in oil, sepia, and watercolor. Afterward his painting style became set, like his subjects, which were entirely

monuments. He probably learned the technique of watercolor during his stay in Italy. His main themes were the splendors of Paris and Rome, and he exhibited regularly in the Salon after 1791. He never abandoned painting despite the success of his numerous architectural projects.

Bibliography : Dalgalio, *Baltard*, Lyon, 1846.

PIERRE-ANTOINE BAUDOUIN
1723–1769

Baudouin, son of an obscure engraver, studied drawing in the studio of Boucher, who had a decisive influence on his art and who gave him his daughter Marie-Amélie in marriage in 1758. In the work of Baudouin, we may rediscover the lost gouaches of Boucher, if we are to put any faith in such contemporaries as Mariette and Diderot, who have described the affinities between father- and son-in-law. Baudouin's gouaches are extremely skillful,

exact, and precise, and yet, like Boucher's paintings, painted with freedom and lightness and a very lively hand. His eminence is thrown into prominence by his imitators, Mallet and even Lavreince, for Baudouin has equal skill and lacks dryness. Perhaps part of Baudouin's success was due to his choice of subjects, which were always gallant and never very erotic. He became an associate of the Academy in 1761 and a member in 1763, and he exhibited there regularly for the few years before his premature death. The absolutely faithful reproduction in his interiors, the irony, even the comic aspects of the scandalous scenes he invented, were surely a true evocation of the life of the nobility in the late eighteenth century.

Bibliography : Bocher, *Baudouin*, Paris, 1875.

LOUIS CARROGIS, called Louis de Carmontelle
1717–1806

Carrogis' father was a shoemaker on the corner of the Rue des Quatre-Vents and the Rue du Cœur-Volant, but since the artist wanted to move in society he adopted the name de Carmontelle. He was a topographical artist during the Seven Years' War, making military relief maps. No doubt he practiced watercolor in this way, and in any event he did portraits and decorative designs for princes such as the Duc de Chevreuse and the Duc de Chartres who were serving in the army.

After the peace of 1763 he accepted a position as a reader to the Duc d'Orléans; it was a minor post and only fairly well paid, but it pleased Carmontelle because it was a point of vantage. For his own pleasure, he sketched all the great and odd people he encountered, sometimes in short plays, in parables presented in amateur theaters, rarely in books, in rough sketches and watercolors that astonished his models and friends. "M. de Carmontelle," wrote Grimm, "has made a collection of portraits in pencil and color-wash. He has a talent for catching the air, the bearing and spirit of a face. Every day I come across people whom I recognize from his sketches. He completes a full-length portrait with astonishing rapidity in about two hours. Carmontelle has made a collection of pictures of all the ladies of Paris. These anthologies, which he constantly augments, give an idea of the varying conditions of men and women of all classes from the Dauphin down to the sweepers of Saint-Cloud."

By chance Carmontelle made a sketch of a boy prodigy, a pianist passing through Paris—it was Mozart. His watercolor is the finest, most touching record of the childhood of the author of "The Magic Flute." That was Carmontelle's contribution: he left a marvelous record rather than true works of art. His technique is rather rudimentary; all his characters are stereotyped, and his watercolors are really carefully colored drawings. He had a gift for making a likeness, but no imagination. He was witty and had perfect taste. His portfolio of watercolors is a gallery of portraits and a repository of the customs and fashions current at the close of the *ancien régime*. You can rely on Carmontelle : in his work there is not a single hair style, piece of silk, or gesture which was not observed from life. While he was in charge of the amusements in the great houses of the Orleans family, he invented a kind of animated magic lantern with a spoken commentary, which he was still trying to sell during the First Empire after the troubles of the Revolution.

Bibliography : Gruyer, *Carmontelle*, Paris, 1902.

JACQUES CHARLIER
about 1720–1790

Inspired by Boucher, Charlier seemed in many ways more like a copyist or imitator. He had neither the realism of Baudouin, nor his vigor, but the technical ability exhibited in the many gouaches and miniatures still in existence seems completely characteristic and original. His method is recognizable by a slightly grained surface strangely reminiscent of pointillism. He handled widely differing subjects with skill and also painted in oils, but, apart from his portraits, mythological nudes constitute his main theme. In the eighteenth century he was so fashionable that his work is found among the collections of Caylus, Blondel de Gagny, and even the Prince de Conti. He received royal commissions for miniatures to be used on decorative snuff-boxes.

Bibliography : Bouchot, *La Miniature française*, Paris, 1907.

CLAUDE-LOUIS CHATELET
1753–1794

Châtelet must have been introduced to landscape painting by the Abbé de Saint-Non, who commissioned him to illustrate his *Picturesque Journey to Naples and Sicily*. Afterward he made the plates for *Picturesque Views of Switzerland*, and painted at least one landscape in England. His principal work is a collection of views of the garden of the Petit Trianon which he did for the Queen, Marie Antoinette, who wanted to send a souvenir of her house to her family and friends. Châtelet painted with skill and charm, but he also executed some strange landscapes in a style heralding Romanticism.

One wonders what could have been the difficulties, the obsessions, the desires that led him to become one of the most violent adversaries of the King and Queen as well of all those noblemen who had been his patrons. He was a member of the Revolutionary Tribunal during the Terror and urged many swift executions, only to be himself guillotined after the 9 Thermidor.

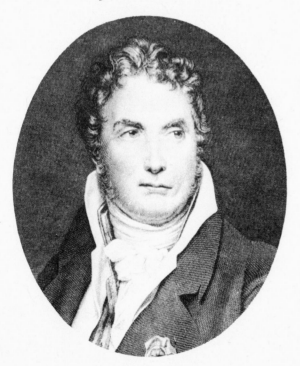

Jacques-Louis David

JACQUES-LOUIS DAVID
1748–1824

This great painter of the Revolution and the Empire, although he drew a great deal, rarely used watercolor. Many sketches exist for David's large compositions, such as the *The Oath in the Tennis-court* and *The Anointing*; but he generally noted the colors in oils. On the other hand, his Italian landscapes are often washed with a brush, though only with sepia. David thus revealed himself to be faithful to the traditions of the painter-historian: it was not till the nineteenth century that Ingres, and Delacroix especially, used watercolor as a matter of course for their preparatory sketches. Apart from rare color washes for mythological subjects, David really only used watercolor for his decorative studies: designs for a card game, for Revolutionary costumes commissioned by his colleagues of the Convention. Possibly the designs, now lost, of the Revolutionary galas may also have been in watercolor. David, in his role of watercolorist, preserved the same freshness and vigor as in his oil paintings, but he uses watercolor as a method of coloring rather than of painting.

Bibliography : J. David, *David*, Paris, 1880.

LOUIS-PHILIBERT DEBUCOURT
1755–1832

As an engraver Debucourt became the symbol of the eighteenth century about fifty years after his death, principally because of a particularly amusing and evocative picture, representing the promenade of the Palais-Royal, in which all social classes are mingling on the eve of the collapse of the monarchy in 1792. All his life, Debucourt showed himself to be an excellent craftsman and skillful salesman. He did engravings of the work of the most fashionable painters —Carle Vernet, Van Gorp, Boilly— published, whenever possible, witty commentaries on the times, and was in easy circumstances till he died. And yet this son of an usher in the Place Maubert had started out as a painter and watercolorist. In oils he painted in a melancholy style, characteristic of the Louis XVI period; both treatment and idea were heavy. His watercolors, however, combining realism with fantasy into an evocation of fashionable stories and poems, were charmingly precise without being dull. The rare watercolors done by Debucourt form an introduction to his celebrated engravings which, it must be added, are often colored.

Bibliography : Goncourt, *Debucourt* in "L'Art du XVIIIe Siècle," Paris, 1883; Fenaille, *Debucourt*, Paris, 1889.

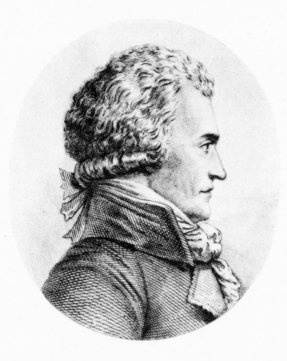

Louis-Philibert Debucourt

PIERRE-ANTOINE DEMACHY
1723–1807

The encyclopedist Diderot had a low opinion of Demachy and never missed an opportunity to stress his inferiority to Hubert Robert. Perhaps Diderot was right, but Demachy is historically important. He awakened a proper respect both for gouache and for the urban scene. Such themes and techniques had previously been reserved for artisans. Demachy was elected to the Academy in 1758, and in 1786 he was a professor, just as if he had been a painter of historical subjects; he opened the way for such pupils and emulators as Huet, Loutherbourg, and Hubert Robert. With the help of his teacher, the architect and painter Servandoni, he had discovered the Italian school. However, his very detailed style lacks poetry. His landscapes are often animated by an amusing and picturesque crowd, but although the scene is evocative it is rather heavy and photographic. His very lack of imagination makes him an indispensable witness of the Paris of Louis XV, Louis XVI, and the Revolution.

Bibliography : S. Bouchery, unpublished thesis, Ecole du Louvre.

JEAN-LOUIS DESPREZ
1743–1804

Although Desprez has not received due recognition, he was a fine artist, architect, theater designer, and visionary painter, and an original and strong personality typical of the late eighteenth century. This son of a wigmaker from Auxerre must have had a strong vocational bent, for he went to Paris while still very young and attended a course run by the architect Blondel, who commissioned him to do some drawings. After several failures, he was awarded the Grand Prix de Rome in 1776 at the relatively advanced age of thirty-three. Pensioned by the King in Italy, and already married, despite the regulations, he was supported more than adequately by Vien, who directed his work and recommended him to Saint-Non as a replacement for Robert and for Fragonard as illustrator for his book *The Journey to the Two Sicilies.*

Between 1777 and 1784 Desprez drew and painted in watercolors on location or in one of his studios in southern Italy, Sicily, Malta, and Rome, and was especially attracted by the ruins of Pompeii, Herculaneum, and Paestum. Sometimes his landscapes are absolutely true to life; frequently apparently equally real scenes were actually invented.

In 1784 in Rome he met Gustavus III, King of Sweden, who was very interested in literature and art; Desprez was thereupon engaged as a director of the Royal Theatre in Stockholm. Charged with the task of designing sets and costumes and organizing *fêtes,* he produced numerous designs in watercolor, and was altogether successful in his new *métier.* Royal patronage also allowed him to make use of his architectural talent, particularly in Stockholm and in the castles of Haga and Drotingholm, where he transformed the theater. He established himself firmly in Sweden, where he was able to follow his often very diverse impulses. By turns a designer of gardens, a painter of battle scenes, and a disciple of Ledoux, he remained in Sweden after the assassination of Gustavus III in 1792. Deprez was supported by Sergel, a very gifted sculptor, though more conventional than the best of his French colleagues, and he developed a Louis XVI style in the Swedish manner, a skillful variation on the French style. In 1804 he died during the reign of a king of Sweden, who, though little interested in the arts, did commission a series of large historical paintings.

Desprez generally drew in pen and ink followed with watercolor. He was a careful observer, and his architectural details add considerable charm to his gay and poetic views.

Bibliography : N. G. Wollin, *Desprez,* 3 vols., 1933–1939.

FRANÇOIS DUMONT
1751–1831

Dumont, born into a poor family of Lorraine, worked for seven years with the chief painter to King Stanislas at Nancy. When he was orphaned at eighteen, he set off for Paris to try to earn a living for himself and his brothers and sisters and was immediately successful. Undoubtedly he had already acquired the art of conversation and of pleasing his models, for in 1769 he was commissioned to paint in miniature the portrait of Madame Valayer-Coster of the Royal Academy. He did so brilliantly. He was patronized by the nobles of Lorraine who frequented the court of Marie Antoinette —then Dauphine —at Versailles. In 1771 and 1773 he was commanded to do portraits of the Comte d'Artois, but his greatest triumph was to be appointed Queen's Miniaturist after 1780. Dumont unceasingly duplicated the likeness of this charming queen, whose attractions so well suited his art. In 1788, although only a miniature painter, he achieved the ultimate glory: he was made a member of the Royal Academy of Painting. He became wealthy and had an estate near Melun adjacent to that of the portrait painter Vestier. In August 1789 Dumont married Vestier's very pretty daughter Nicole, who was also a gifted artist. They had three children.

But the days of trial were approaching. Loyal to the Queen, of whom he had painted a last portrait in classical style in 1791, Dumont was imprisoned in the Abbaye under the Terror but was saved by the fall of Robespierre. Under the Empire and subsequent Restoration, commissions flowed in and François Dumont's work was still much in demand when he died. (His technique, somewhat influenced by the innovations made by Hall, changed miniature painting into a form of enameling that was very lively, if far from conventional.)

Bibliography: H. de Chenevières, *François Dumont*, in "Gazette des Beaux-Arts," 1903, pp. 170–183.

LOUIS DURAMEAU
1733–1796

One of the most popular painters in France at the time of Louis XVI, and the one most unjustly forgotten today, Durameau owes his present oblivion to his earlier success. An original and brilliant decorator, he lacked the easy facility of Robert, although he received the finest commissions; the ceiling of the opera house in the Palais-Royal, since destroyed, and the paintings for the gallery of Apollo in the Louvre were his work. His exquisite decoration for the Gabriel theater at Versailles has only recently been discovered. Other paintings, formerly well known, dispersed among churches and provincial museums, have never been collected or reproduced. He was a professor at the Academy of Painting and keeper of the king's pictures and as such was heaped with honors. Influenced, as was Fragonard, by great Italian decorative painting, he too invented a brilliant style that was both mythological and realistic. In the judgment of history, no one was able to break away more completely from the neoclassical movement than Durameau. However, a gouache painted in Italy and handed down to us shows him to be one of the first painters to observe clearly the toil of laborers.

Bibliography: J. Locquin, *La Peinture d'Histoire*, Paris, 1912.

JEAN-HONORÉ FRAGONARD
1732–1806

Fragonard, with his great superiority over his contemporaries and the variety of his inspiration, coupled with the alternation between prodigious success and indifference which he suffered both during his lifetime and after his death, presents a bewildering picture. Born in Provence, he left Grasse for Paris as a child. His enthusiasm for painting caused him while still very young to enter Boucher's studio and, after he had won the Prix de Rome, to continue his studies in Italy until he was past thirty. He may have started painting in watercolor during his time in Boucher's studio, where so many varied techniques were practiced, but certainly he did so in Italy where there were so many watercolorists.

Fragonard worked in every style: he painted religious, mythological, or erotic scenes, portraits, landscapes, imaginary or realistic views, and used the techniques of drawing, engraving, certainly miniature painting, gouache, and watercolor, as well as oils. But if he painted overdoors or vast panels with the same facility as easel pictures he was never simply a decorator, nor did he design theater sets, models, or costumes for *fêtes*. He reserved his watercolor painting for realistic subjects, an indication that he probably worked from nature. Although the wash drawings have today disappeared, eighteenth-century sale catalogues testify to their number. Many of them must have been landscapes done in Italy.

Nothing could be more simple and true to life than Fragonard's unmade bed or his pretty girl with a kerchief. His charm rested in his ability to express everything with

a disarming discretion. He was never entirely a water-colorist, and in this he showed himself to be a man of his time, but he took advantage of the medium to complete, improve, prolong, and refine everything he expressed in his drawing. However, his watercolors, although few in relation to his entire *œuvre*, may still offer a key to his genius, for undoubtedly this new technique somehow influenced his conception of painting and perhaps, also, of drawing. His most successful canvases, such as the *Fête à Saint Cloud* or *Feu aux Poudres*, retain a sense of the impromptu, of details noted on the spot, which was something new in French art, and his execution reveals a play of transparent colors that is completely characteristic. This bias toward improvisation, this attempt to give an impression of life and to make an accurate record, is not unconnected with watercolor. The drawings, too, so often washes, have watercolors that are a little faded. Would it be possible to distinguish, out of the entire *œuvre* of this painter, the commissioned works which, while always competent, were also often overdone, from the true outpourings of his genius? The watercolors are full of life and belong necessarily to the second category, but the late paintings are evidently examples of his commissioned works.

Fragonard's greatness, his superiority, lies in the freedom and lack of restraint which gave his most successful creations the same quality as the masterpieces of Impressionism —re-creating life, rather than evoking it. Thus, the creations of Fragonard, who was so profoundly a watercolorist and yet produced so few of them, support the proposition that in England and Italy the *aquarelle* was probably a technique used wherever it was convenient, whereas in France it was rather a state of mind: the century of Poussin and the period of Ingres logically coincide with an eclipse of the French watercolor, whereas Renoir, Degas, or Cézanne, with their desire for spontaneity, rediscovered its freshness.

Bibliography : G. Wildenstein, *Fragonard*, London, 1960; J. Thuillier, *Fragonard*, Paris, 1967.

CLAUDE GILLOT
1673–1722

Gillot's work falls at the juncture of two centuries. He was the very gifted son of a painter, decorator, and embroiderer from Langres. In Paris, his first master was an uncle of the great Mariette. His impulsive temperament led him to neglect traditional subjects of religious and mythological painting, and he was successful enough in this to be elected to the Academy and to create a new speciality, a form of reportage then called "modern subjects," which subsequently received the title of genre painting. The events evoked by his drawings and engravings for almanacs, though he also did some painting, included the humblest events in the theater, the weather, financial crises, or great political events. Watteau, a pupil and friend of Gillot, was to bring genre painting to its height of perfection. Gillot, an innovator in the world of inspiration, seems also to have sought new techniques. He was one of the first of the official painters to use watercolors regularly, either as aquarelle or in the form of gouache. The term gouache was used for the first time in connection with his work. The Louvre possesses about twenty of his works: gouaches, watercolors, and colored drawings. Gillot was a painter, decorative artist, theatrical designer, and even a caricaturist, constantly mixing his styles. Watteau's splendid work has unfortunately eclipsed that of Gillot, who was the true inventor of realistic painting and of watercolor in eighteenth-century France. His was a chronicle full of vigor and in charming taste.

Bibliography : Dacier, *Gillot*, in Dimier, *Les Peintres Français du XVIIᵉ Siècle*. Paris, 1928, vol. I.

JEAN-BAPTISTE HILAIR
1753–about 1822

Hilair's work is limited but airy, sensitive, charming; for decades his name was spelled wrongly, and his existence totally obscure. His birthplace is known; and when he exhibited at the Coliseum in Paris in 1776 and in the Salon de la Jeunesse in 1780 he was known to be a pupil of Leprince to whom, however, he was superior. Hilair accompanied the Comte Choiseul-Gouffier to the eastern Mediterranean and contributed to the illustrations for his *Picturesque Journey to Greece*; he illustrated the *Fables* of La Fontaine, suggesting Russian and Turkish subjects. But Hilair was at his best as the chronicler of the early days of the Revolution, representing with naïve cheerfulness another side of the scene. Under the Terror, Hilair depicted the King's garden full of happy strollers. In the Place de la Révolution he saw, not the guillotine, but a group watching a puppet. He was a pure watercolor artist, using vivid colors, much diluted and crushed rapidly onto light paper. The work of his last years is not known. No doubt by then not many connoisseurs remained.

Bibliography: Henry Marcel, *Hilair*, in "Revue de l'Ancien et Moderne," 1903, pp. 207–216.

Hubert Robert

CLAUDE HOIN
1750–1817

Halfway between an amateur and a professional, Hoin would probably be better known as the energetic Director of the Dijon Museum than as a painter were it not that the Goncourts placed him rightly among the best painters of the eighteenth century. This son and grandson of surgeons and jewelers of Dijon expressed in his gouaches, watercolors, and drawings an exquisite human sympathy and a moving feeling for nature, although very few of his paintings are known. He worked somewhat apart from the mainstream, a little like Prud'hon, his compatriot and fellow student under François Devosge, director of the Ecole des Beaux-Arts of Burgundy. When he was about twenty Hoin went to Paris, where he became acquainted with the court, all the fashionable painters, and the theater. At one time he became painter to Monsieur, Louis XVI's brother, but as a rule earned his living modestly. In 1802 he returned to Dijon and became professor of drawing at the Lycée, then director of the museum. His miniatures seem frequently to be commissioned works and are rather heavy, like his pastels. Hoin was never a brilliant master of his craft, but his large drawings, enhanced with white pencil or color, his watercolors and gouaches, have the simple charm of confidences. Hoin has

a fresh approach that should not be confused with lack of skill. It is enchanting. He is a lyric poet and not, as were so many of his contemporaries, just an excellent craftsman. Watercolor was a medium especially suited to his talent, for he loved its liquid flow and transparency.

Bibliography : Portalis, *Hoin*, Paris, 1900.

JEAN-BAPTISTE HUET
1745–1811

A facile, many-sided, and prolific artist, Huet's gifts were those of the society in which he lived; although he does not outstrip his contemporaries he embodies these qualities better than many of those who were more gifted. Born in the Louvre, where his father, painter of coats of arms in the Garde Meuble under Louis XV, had lodgings, he may not, as his writings testify, ever have learned grammar or spelling, but he must have known how to draw, paint, and engrave at an age when most children are running about amusing themselves. His teacher was Leprince, but in the Louvre he certainly must have encountered all the great artists of the day and profited from their advice. In any case, he started by following in the steps of Oudry, painting country scenes and lots of sheep. The landscapes and studies of the urban Huet are sincere and exact. As soon as circumstances allowed he bought a house in the country near Paris, and then an agricultural estate. But this new taste for nature, characteristic of his period, did not prevent him from making mythologically inspired paintings in the style of Boucher and many ornamental drawings and engravings. He learned his technique of watercolor either from Leprince or Oudry. As he experimented with all kinds of methods in both painting and engraving, it is not surprising that he was also attracted by watercolor. But he loved drawing too much, was too fond of delicate impressions, to have liked gouache. He amused himself by enlivening his drawings with color. Neither his ideas nor his style are particularly original, though nothing is unskilled or heavy. The effect is light and graceful. This explains his election to the Academy at twenty-four, and the success of pieces he sent for exhibition to the Salon. The Revolution forced him to change his patrons without a noticeable change in his pastoral scenes. In the Salon of 1800 he exhibited landscapes and paintings of sheep. Twice married, he had three sons, all painters and engravers. He died a poor man, and forgotten, at the age of sixty-seven.

Bibliography : G. Gabillot, *Les Huet*, Paris, 1892.

NICOLAS LAFRENSEN, called Lavreince
1737–1807

Lavreince, although Swedish, was inspired by the Parisian milieu and created works that were as French in their execution as in inspiration. His father was a miniature painter and must have initiated his son in this art; it may have been his premature death that prompted the young Lavreince to try his luck in Paris. In the eighteenth century Sweden was closely linked with France, where the exploits of Charles XII and Gustavus Adolphus were followed with excited interest. When Lavreince arrived in Paris about 1765 he was welcomed into the small colony of Swedish artists led at that time by Roslin and later by the most fashionable French painters. Baudouin, Boucher's son-in-law, then at the height of his power, showed him the method of painting elegant subjects rapidly in gouache, a technique easy for a miniature painter to acquire. Probably at that date Lavreince was copying Boucher's pictures and Baudouin's subjects in gouache. Apparently tired of the life, he left to reappear in Stockholm in 1769; but he remained there five years at most and then returned, drawn by nostalgia for the passionate activity of a French artist's life. On his return he found Baudouin dead and his works published as engravings. Lavreince took up with more skill than originality the path traced by his master. He records with witty and detailed naïveté the events of everyday life among the aristocracy—worldly and amorous encounters full of intimate gesture. Lavreince is less gallant than Baudouin and probably not less realistic. He was very successful, but during his lifetime he never achieved the fame of his teacher. Revolution drove Lavreince regretfully back to Stockholm, where he took up his career as a portrait miniaturist. He was almost completely forgotten when he died in Stockholm in 1808.

Bibliography : Lespinasse, *Lavreince,* Paris, 1928; Wennberg, *Nicolas Lafrensen,* Malmö, 1947.

CLAUDE-MATHIEU DE LA GARDETTE
1762–1805

This architect, son of one of the king's gardeners, is recognized today primarily as a landscape architect and a theoretician, for he constructed very few buildings. After he left the School of Architecture in Paris he designed a project for a Temple of Friendship in 1784 and published an essay entitled *Elementary Principles of Shadow in Architecture.* He won the Prix de Rome for architecture in 1791 and used it to study the ruins of Paestum in Naples. In the Salon of 1800 he exhibited models for memorials for the Revolutionary wars, and he died in the post of Professor of Drawing and Architecture at Orléans. At the height of his career he received the commission for the fine watercolors of the park at Chantilly in 1787. It was the counterpart to the portfolio of the Trianon ordered from Châtelet by Marie Antoinette. The watercolors of La Gardette, larger, more spontaneous, and bare of all artistry, form an unsophisticated record of the finest princely garden of the eighteenth century.

Bibliography: Herbuison and Leroy, *de la Gardette,* in "Réunion des Sociétés des Départements," 1896, pp. 513–529.

JEAN-BAPTISTE LALLEMAND
1716–1803

Lallemand was an unusual example of an artist with considerable facility and imagination, capable of painting to order the most varied subjects in different countries. Born at Dijon where his father was a tailor, he did not give himself entirely to art until late in life. Accepted as a Master Painter at Dijon in 1744, he went to Paris, then to Rome, where he painted pictures of ruins. He probably sold them on one of his brief sojourns in Paris. His stay in Rome ended; in 1770 he was back in Dijon, and he also painted in London. In oils, he painted interiors, seascapes, watering places, and landscapes. His gouaches are principally urban scenes of Rome or Paris (and these form the best part of his work, being well observed and wittily expressed). During the Revolution, and possibly a few years before, he lived in Paris, where, before he died in 1803, he had the opportunity to record as an eyewitness some of the sudden changes of fortune of the time.

Bibliography : P. Quarre, *Catalogue de l'Exposition Lallemand,* Dijon, 1954; Cl.G.Marcus, *Lallemand,* in "Art et Curiosité," January–February, 1966, pp. 5–10.

JEAN-BAPTISTE LE PAON
1738–1785

During the Seven Years' War Le Paon was a soldier and amateur painter. Later, under the direction of Casanova, he became a painter of battles and hunting scenes. Exhibiting regularly in the Salon de la Correspondance, he

became First Painter to the Prince de Condé and was given commissions by Louis XVI and Catherine the Great. In this capacity he made a series of paintings illustrating the exploits of the Grand Condé for the Bourbon Palace. During the American Revolution he painted portraits of Washington and Lafayette. He made many drawings of soldiers and huntsmen, and his pen sketches are often washed with watercolor. His career as a painter was very brief.

Bibliography : Nolhac, *Le Paon*, in "L'Art," 1901, pp. 493–501.

JEAN-BAPTISTE LEPRINCE
1734–1781

Leprince was a member of a very old Norman family of artists who had been painters, sculptors, gilders, and musicians since the seventeenth century, and possibly earlier. One of them settled at Metz in the early eighteenth

Jean-Baptiste Leprince

century. The elder Jean-Baptiste Leprince was a master sculptor with many children. One son was a musician, another a geographer; a daughter married a professor of languages at St. Petersburg; and the most famous was Jean-Baptiste, well endowed for society and the theater,

but even more for engraving, painting, and watercolor. He grew tired of Metz while still a boy and was fortunate enough to obtain the support of the Maréchal de Belle-Isle, who was a descendant of Fouquet and governor of the fortress of Metz. With this high patronage, Leprince was enabled to join the studio of François Boucher. He married a rich *bourgeoise* a good deal older than himself, spent a large portion of her dowry, and then left her, finding himself at the age of twenty endowed only with contacts and a slight talent.

He traveled to Italy, apparently did not like it much, went to Holland for a brief period and then to Russia, where he fell into ecstasies over the beautiful landscape and charming people. (He stayed three years working for the Tzars and gathered an enormous collection of drawings made on his extensive trips into the provinces.) He returned to Paris in 1763, and there all his work in oils, watercolors, drawing, and engraving was inspired by Russia. An academician, a brilliant artist, much in demand, he set the fashion for Russian landscapes and peasant scenes.

Watercolor was a natural means of expression for him, as he was interested in color rather than in line. He must have met watercolor painters in Italy and Flanders and discovered a new technique of engraving "in the style of a wash," which allowed certain effects of watercolor to be reproduced. The clever, cheerful art of Leprince reflects the life he led. He was on good terms with his colleagues and mingled freely with the great, but he was not strong and his health was impaired by an existence overburdened with work and festivity. He died in 1781.

Bibliography : Hédon, *Leprince*, Paris, 1879.

LOUIS-NICOLAS DE LESPINASSE
1734–1808

The little-known artist the Chevalier de Lespinasse was so highly regarded by the members of the Royal Academy that he became one of the first landscape artists and water-colorists to be received as an associate member in 1787. Although he had regularly contributed drawings for the plates published in the *Description Générale et Particulière de la France* between 1781 and 1798, the only landscapes we know are those which he exhibited regularly at the Salon: they have the minute precision of architectural plans, yet an elegance of line and accuracy of color endow them with a real aesthetic value. They are huge panoramas, done, like the plans of the time, as if they were views taken from

an imaginary height. The obvious attempt to be exact in every detail make the watercolors of Lespinasse, whose oils were not numerous, invaluable documents.

JEAN-BAPTISTE MALLET
1759–1835

Mallet was a follower, not a leader. He prolonged the art of Baudoin and Lavreince with equal freedom, but a less sure hand. His interiors are more bourgeois. He preferred to paint landscapes inspired by real scenes. Mallet's works are generally more geometric, and also more fluid, than if they had been executed more quickly. He was certainly an attentive observer, for his work reveals not only the fashions of the day, but the way customs changed. He was as skilled in gouache and watercolor as he was oils, and his work developed from the light and charming manner of the eighteenth-century watercolorists to a style of such precision as to be a forerunner of the genre paintings of Meissonier—or even of photography.

Jean-Michel Moreau

JEAN-MICHEL MOREAU, called Moreau the Younger
1741–1814

Moreau was a Parisian, the son of an active craftsman, at first a wigmaker and then a maker of faïence. His brother was the landscapist Louis Moreau; his father before him had dedicated himself to painting. His marriage to a woman who was the daughter of a sculptor and also the niece of the owner of a bookshop helped him to gain access to the world of illustration. At seventeen he went for a brief journey to Russia with his master, but on his return became an engraver under the direction of Le Bas. As he was a skilled and talented draftsman, Cochin obtained for him the post of designer and engraver to the King's cabinet. In this capacity he recorded *fêtes* and great events at court, from the marriage of the future Louis XVI in 1770, his coronation, and the *fêtes* held to honor the birth of the Dauphin, to the Assembly of the Estates General. He also did several very precise, exact, and vivid compositions, showing the clothes and customs of his day, and many illustrations for Rousseau, Voltaire, and all the most famous contemporary writers. He only used watercolor occasionally, to color his drawings of the *fêtes* to be given by Madame du Barry at Louveciennes and to show the colors of the costumes when Gluck's *Iphigénie en Tauride*

was to be presented in Paris. Moreau was chiefly concerned with the idea of completing his drawings rather than actually producing watercolor paintings. Although he was enthusiastic about the new ideas, Moreau could not really have welcomed the Revolution. His style went out of fashion and he even seemed to grow less competent, so that he was forced to earn a living by illustrating and by teaching drawing. He was not well regarded under the Empire and it was too late when at last, with the restoration of the Bourbons, he was given the official position he had formerly held at court. He died on November 30th, 1814.

Bibliography : Bocher, *Moreau*, Paris, 1880; A. Moreau, *Les Moreau*, Paris, 1893.

LOUIS MOREAU, called Moreau the Elder
1739–1805

Louis Moreau was the elder brother of Jean-Michel Moreau. Unlike his younger brother, Louis was never famous during his lifetime and received no academic distinction. His work, however, was much more original and displays an emotion that has survived until today.

The events of his career are not well known and in any case tell little about his work. In 1760, 1761, and 1762, he exhibited several landscapes in the outdoor exhibition

called "de la Jeunesse" held in the Place Dauphine. At that time he was a pupil of Demachy, and from this skilled recorder of the Parisian scene he learned gouache and possibly even watercolor painting, both of which techniques his teacher had acquired from Servandoni, himself a pupil of Panini. But the relationship is deceptive; Moreau may have been as exact and realistic as Demachy, but he was far more sensitive and lyrical. Subsequently Moreau followed his profession at the Saint-Luc Academy, an ancient guild reserved for those who had no royal patrons. He was an adviser and professor and exhibited regularly with his colleagues in the Salon de la Correspondance. Several of his works were engraved and used as illustrations. At the very end of the *ancien régime* he sought admittance to the Royal Academy of painting, of which his brother was a member, but without success. However, about that time he obtained lodgings in the Louvre and a minor post as painter to the Comte d'Artois. The Revolution actually benefited him because it gave him the right, with all other artists, to exhibit in the Salon of the Louvre. He took an interest in the rehabilitation of the Louvre collections and became keeper of the museum's pictures. He was painting until just before he died and was still exhibiting at the Salon in 1804. He died leaving a wife but no children.

Moreau was an independent artist who seems to have sold his work without difficulty and to have been held in disfavor by contemporary art critics. He traveled and walked a great deal along the streets of Paris, among the châteaux and countryside nearby, and along the Loire. He painted Valençay, and undoubtedly also in Normandy and perhaps also in Provence. Moreau was not at all interested in people, merely recording them as figures. But his feeling for nature, or rather for the colors of the sky and for the atmosphere, is much nearer to the response of the Impressionists than to that of his own day. He painted the romance of trees, sun, fine landscapes, but not ruins. His choice of drawing, watercolor, or gouache always depended on the demands of the scene.

Bibliography : G. Wildenstein, *L. Moreau*, Paris, 1923.

JEAN PILLEMENT
1728–1808

Pillement is a painter for whom life was a reflection of his work, filled with fantasy and variety. He was born into a family of painters from Lyons and seems to have started life by painting on silk, but he had a taste for traveling and left Lyons for Paris, where he designed for the Gobelins and continued with his studies. But in 1745 he went to Spain, staying about three years at Madrid, where he decorated rich men's houses and sold his paintings. He was immediately successful in Lisbon but remained only a short time because he had the opportunity to go to London, and there he stayed about ten years and discovered the two styles in which he was to excel : *chinoiserie* and landscape. At that time, too, he must surely have started to use watercolor for his drawings of Chinese costumes and to enliven his skies.

About 1760 he was to be seen in Paris, Turin, Rome, Milan, Vienna, Berlin, Bonn, Warsaw, and then Lyons. His incessant wanderings did not prevent him from exhibiting his work occasionally in Paris. In 1778 he was working for Marie Antoinette at the Petit Trianon and was awarded the title of Queen's Painter in 1779; he sold his pictures very successfully in London. Then he returned to Portugal, where commissions abounded, and probably stayed there about ten years or more. In 1796 he returned to Pezenas in France. He was quite impoverished and went back to Lyons to be near his son, who was an engraver. He was still working just before he died at the age of eighty.

Pillement loved to invent characters, costumes, landscapes, even flowers and animals, and his whole art was an effort to charm, please, and entertain. Every method suited him—oil, gouache, colored chalks, or watercolor. His work, which is scattered everywhere across Europe, is considerable, and is generally recognizable by a freedom and animation well suited to watercolor. When Pillement offered his services to the Marquis of Marigny, Louis XV's Minister of the Arts, he sent him a wash drawing.

Bibliography : G. Pillement, *Pillement*, Paris, 1945.

PIERRE-JOSEPH REDOUTÉ
1759–1840

The singular thing about Redouté's work is its unity. He was born into a family of painters at Saint-Hubert in the Belgian Ardennes. As a boy he traveled through Flanders and Holland, where he discovered the flowers of Van Huysum, and, fired with enthusiasm, he never ceased, thereafter, to paint flowers in watercolor and gouache. In 1782 he settled in Paris and made the acquaintance of the naturalistic painters, the engraver Demarteau, and Van Spaendonck, who was the most fashionable painter of the King's garden and whom he helped to reproduce on

Pierre-Joseph Redouté

nard and the Abbé de Saint-Non, but was also greatly influenced by Panini and the Venetians as well as by Piranesi and the neoclassicists. He was the first French painter to make a reputation with his fine watercolors done in the manner of the Italian landscape painters. The pieces he sent to the Salon in 1765, all landscapes, were very successful, but, in the words of Mariette, "his paintings [are] really inferior to the drawings, which are full of spirit. And those that are slightly colored are much in demand." In fact, Robert enriched some very elaborate and often very large drawings with watercolor. Having become a decorator of houses, a theatrical designer, and the organizer of the Queen's *fêtes* and those of the nobility, Robert subsequently used the technique of watercolor for costumes, sketches, and designs.

Robert, sincerely attached to the royal family, for a long time was a prisoner under the Terror, narrowly escaping the guillotine. He never recovered the position he had held under the *ancien régime*, although he worked hard during his ten last years, probably for collectors who still loved an art that had grown unfashionable in the eyes of the critics. His imaginary landscapes, generally embellished with ruins and painted in oils or watercolor, are sometimes signed in the first years of the nineteenth century.

Bibliography : P. de Nolhac, *Robert*, Paris, 1910; Gabillot, *Robert*, Paris, 1895.

parchment the most beautiful and interesting plants of the royal collections. Marie Antoinette liked his work and so he painted flowers at Trianon, receiving the title of Painter to the Queen's Collection. He had no commissions during the Revolution but continued painting in watercolor, especially roses and lilies. The Empress Josephine, wife of Napoleon I, commanded him to paint her rose garden at Malmaison, and the fashion for gardens in the Romantic period assured his increasing popularity. He taught the art of watercolor to empresses, to the daughter-in-law of Charles X, and to the wife and daughters of Louis-Philippe. The first half of the nineteenth century produced a veritable cult for Marie Antoinette's flower painter.

Bibliography : Mirault, *Notice sur Redouté*, Paris, 1845.

HUBERT ROBERT
1733–1808

Robert was the son of bourgeois parents in very easy circumstances, and completed a full course in the classics before he realized that painting was his vocation. An amusing guest and brilliant conversationalist, he came under the protection of the future Duc de Choiseul and was thus enabled to stay in Italy without competing for the Prix de Rome. His talent was truly formed there between the years 1754 and 1764. He was acquainted with Frago-

AUGUSTIN DE SAINT-AUBIN
1736–1807

Augustin, the youngest of the Saint-Aubin brothers, was for a long time the most famous. He was the only one to be elected to the Academy and to exhibit regularly in the Salon. He became fashionable principally as an engraver but also as a portraitist in lead pencil, making very good likenesses, it was said, in the style of Cochin. He was a pupil of Cars and Fessard and in 1776 was awarded the title of Engraver to the King's Library. He reproduced all kinds of works with ease and aptitude. His brothers had put pencil and brush in his hand when he was a small child, and all his life he had made watercolor's or, rather, colored wash drawings, in which one finds, to a lesser degree, the fascination of the everyday scene expressed so much more ably by his brother Gabriel. Four large works, done about 1759 and unknown when his engravings were at their most fashionable, today seem the best things he did.

Bibliography : E. Dacier, *Gabriel de Saint-Aubin*, vol. I, pp. 16–23, Paris, 1929; Bocher, *A. de Saint-Aubin*, Paris, 1879.

Augustin de Saint-Aubin

contemporary Restif de la Bretonne, whose literary paintings have the same quality of intense, hallucinatory truth. The most banal scene becomes a drama or captivating comedy in the hands of Saint-Aubin. He was primarily a colorist even when handling pencil; but he was not interested in current trends. He was a painter of light and shade. His composition is vibrant with light, and the watercolor or gouache tones, often sober and discreet, are the spark which brings it to life. Gabriel de Saint-Aubin is certainly one of the great masters of all time and it was he, alone among the eighteenth-century artists, who discovered the extraordinary power of watercolor.

Bibliography : E. Dacier, *Gabriel de Saint-Aubin*, 2 vol., Paris, 1929.

GABRIEL DE SAINT-AUBIN
1724–1780

The best biography of this dilettante of genius was written by his elder brother, Charles-Germain, who was a great admirer of his younger brother's gifts, but also shocked at his indifference to success. "Born on the 14th of April, 1724, Gabriel displayed from earliest youth a decided liking for study; however, he did not take kindly to convention, but followed his own bent and learned to paint and draw in the studio of Sarasin. He produced, too early, small compositions overly full of knowledge and details and won a major prize at the Royal Academy. He executed some paintings, gathered a few pupils, and spent his life drawing anything he fancied. Objects in sales would be sketched in the margins of the catalogues, clearly enough to be recognized. He had an exceptional memory, spoke well, and was noticeable for his talent and untidiness everywhere he went. Greuze was right when he said he had an unbridled ardor for drawing. As a result of completely neglecting all simple rules of health he died in an exhausted condition on the ninth of February, 1780, leaving his clothes in great disorder and four or five thousand unfinished drawings."

This strange man, despite his broad talent, certainly never painted an "important" picture. He seems to have been engrossed in the immediate representation of the events taking place before him, and in this is similar to his

MARIE DE SAINT-AUBIN
1753–?

Marie was the daughter of Charles-Germain de Saint-Aubin, the greatest embroiderer of his day. She led a simple, bourgeois existence because her father had married her at twenty to Jacques Roch Donnebecq, feather-dresser to the King : "a good boy," said Charles-Germain, "with more steadiness than wit." But the atmosphere in this family of artisans was such that every one of them practiced some form of art. Happily all of them collaborated in a family album which has fortunately survived, called *Le Livre des Saint-Aubin*, into which famous painters, amateurs, and young members of the family stuck their drawings and watercolors. Certainly Marie de Saint-Aubin did not have much skill; but everything is simple, fresh, and discriminating in her agreeable watercolors, which relate much about the amateur artists of the eighteenth century. In those days even feather-dressers had a fine and delicate sense of color. Many more equally attractive watercolors, created for pleasure by unknown artists, may be waiting to be rediscovered and saved by vigilant amateurs.

Bibliography : E. Dacier, *G. de Saint-Aubin*, 2 vol., Paris, 1929.

GERARDUS VAN SPAENDONCK
1746–1822

Van Spaendonck was the first artist to have one of his watercolors entered in the official catalogue of an exhibition. He was born at Tilburg and learned to paint in

Gerardus van Spaendonck

by his Flemish education than Redouté and remained a very precise painter, whose realism lacks something of the grace and elegance of the French style. He was considered so brilliantly superior by his contemporaries that he was the only painter chosen with David to be a founder-member of the Académie des Beaux-Arts, when that institution was created under the Empire.

Bibliography : Quatremère de Quincy, *Eloge de Van Spaendonck*, Paris, 1822.

Holland and Antwerp. He created still lifes in oils and watercolors under the influence of Rachel Ruysch and Van Huysum. In 1770 he came to Paris, where he rapidly gained success as a decorator of precious *objets* as well as at a painter. He very soon became an associate of the Academy, exhibiting regularly, and was elected a full member in 1791. As a painter on parchment attached to the King's garden, he followed a tradition already two centuries old by reproducing studies of the finest flowers of each year. He continued steadily in this task during the Revolution and the Empire. He was more deeply influenced

LOUIS-JOSEPH WATTEAU, called Watteau de Lille
1731–1798

Nephew of the great Antoine, Louis-Joseph was an agreeable provincial painter. Instead of abandoning Valenciennes for Paris, where he stayed for a year or two as a student, he settled in Lille, the chief city of his native Flanders. Louis Watteau was a realistic painter who often sketched the troops encamped round this frontier town, and sometimes the citizens and peasants. These were the subjects for northern caricature during the seventeenth century, a tradition which still existed in Flanders. Watteau de Lille was, like his forerunners of the preceding century, a watercolorist only on occasion, but he displays a certain eighteenth-century gaiety which is very French. Louis Watteau contributed to the success of the arts in Lille in his capacity of professor and cofounder of the School of Drawing in the town, and as an organizer and exhibitor at the annual Salon. His paintings form an impressive chronicle of the Revolution and the war in northern France.

Bibliography : Poncheville, *L. et F. Watteau*, Paris, 1928.

This book was printed
by Paul Attinger,
master printer of Neuchâtel,
after a design by André Rosselet.
The photolithography was executed
by Atesa, Geneva,
and the plates by Gravor, Bienne.
The binding is by
Mayer & Soutter, Renens.

Printed in Switzerland